D0231994

For Denis Roberts whose interest in
modelling encouraged me to do this book
and whose photographs so well illustrate it.

Modelling in Clay

Dorothy Arthur

with photographs by Denis Roberts

A&C Black · London

First published in Great Britain 1993
A & C Black (Publishers) Limited
35 Bedford Row, London WC1R 4JH

Reprinted 1997

ISBN 0-7136-3717-X

Cover illustrations:
 front: a portrait of Charles by the Author
 back: the Author at work

Photographs by Denis Roberts

Designed by Janet Watson

Filmset by Florencetype Ltd, Stoodleigh, Devon
Printed in Great Britain by Butler and Tanner
Ltd., Frome

Contents

INTRODUCTION

Modelling from life is really not as difficult to do as many might think and the interest and pleasure that can be obtained, even with a first attempt, can enthrall a sculptor for life. Progress in the art can be surprisingly rapid if the artist knows where to begin, what materials are needed, how to make an armature and how best to use the clay. Unfortunately, tuition in this art form is not often easily obtained.

My aim in this book is to provide the student with a step-by-step guide to modelling in both clay and terracotta. The examples shown include both portrait and figure work. I have discussed moulding and casting, preparation for kiln firing, bronzing and mounting the models. I have also briefly mentioned other materials such as ciment fondu and fibreglass which can be used for casting and silicone and vinyl which can be used for flexible moulding.

Modelling can not only give the artist great pleasure but it can also provide a satisfactory career. The scope for modellers can range from portrait sculpture to architectural models and friezes to models for films and the theatre. The opportunities are great and the pleasure that can be derived from the work enormous.

I hope that through this book I can introduce others to the joy and pleasure that I have received in a lifetime of modelling in clay.

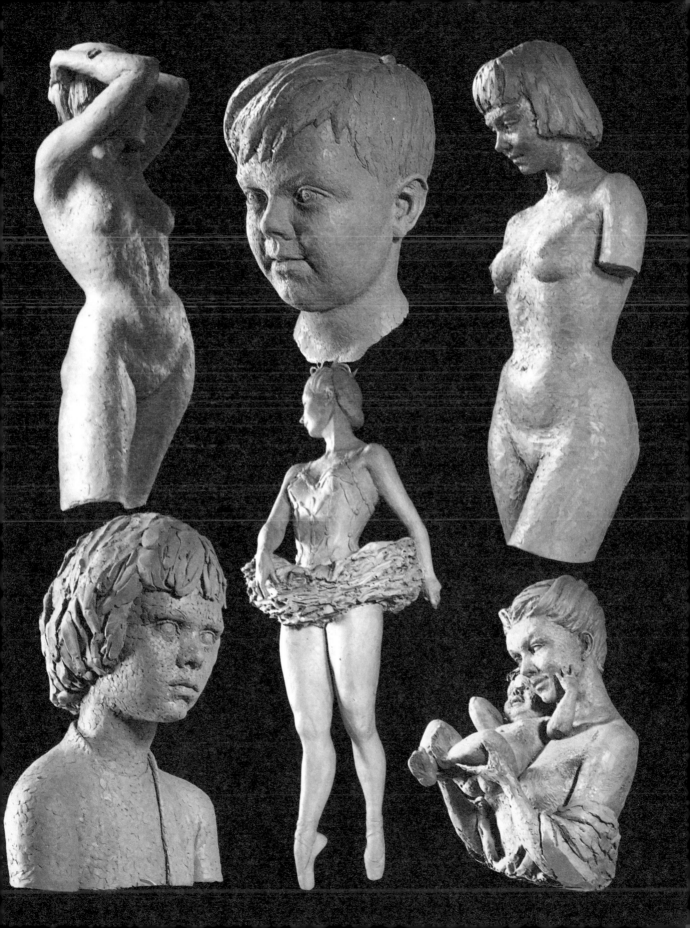

MATERIALS AND EQUIPMENT

In time the sculptor will accumulate a varied selection of equipment that will suit his methods. Below is a list of the basic essential tools that are needed for clay modelling and making armatures. Many of the tools will be found already around the house. Others can be easily obtained from local ironmongers and art shops. Only a few items will need to be purchased from specialist pottery suppliers. (See list on p. 127.)

About clay

Clay can usually be obtained from a local potter or from a pottery supplier. The sculptor will soon find by trial and error which clay he prefers to work with. Most sculptors will use an earthenware clay. The earthenware clays are divided into whitish clays termed White or Buff and red clays which are called terracotta. Many sculptors favour using grogged clay for their work. This is clay that has ground, already fired clay particles added to it. It gives a pleasing texture to the clay.

Clay terms used in the book

Working condition of clay refers to clay in a perfect condition for modelling i.e. neither too wet nor too dry. It should leave your fingers clean while working.

Leatherhard refers to clay that has been allowed to dry out enough so that it can be handled and worked with a metal tool without any damage.

Clay slip refers to clay that has been watered down and smoothly mixed into a cream-like consistency. It is best kept in lidded jars. It is used as a separator when moulding with plaster of Paris.

Clay banding refers to clay that has been rolled out to an even thickness and then cut into strips. It is used for seam separations when plaster moulding.

Materials and Equipment

1. Revolving bench stand
2. Baseboard
3. Pegs
4. Boxwood tools
5. Revolving cake icing stand
6. Modelling tools
7. Griffon
8. Calipers
9. Plastic bowls
10. Small rubber pot (or ½ rubber ball)
11. Scissors
12. Plaster scoop
13. Clay cutter
14. Scopas sketch stand
15. Jute scrim (sold in rolls or by the yard)
16. Casting plaster
17. Plastic bin
18. Brass fencing 'shim'
19. Clay
20. Water spray
21. Knife
22. Mallet
23. Pincers
24. Wire cutters
25. Pliers
26. Chisel
27. Palette knife
28. Hammer
29. Screwdriver

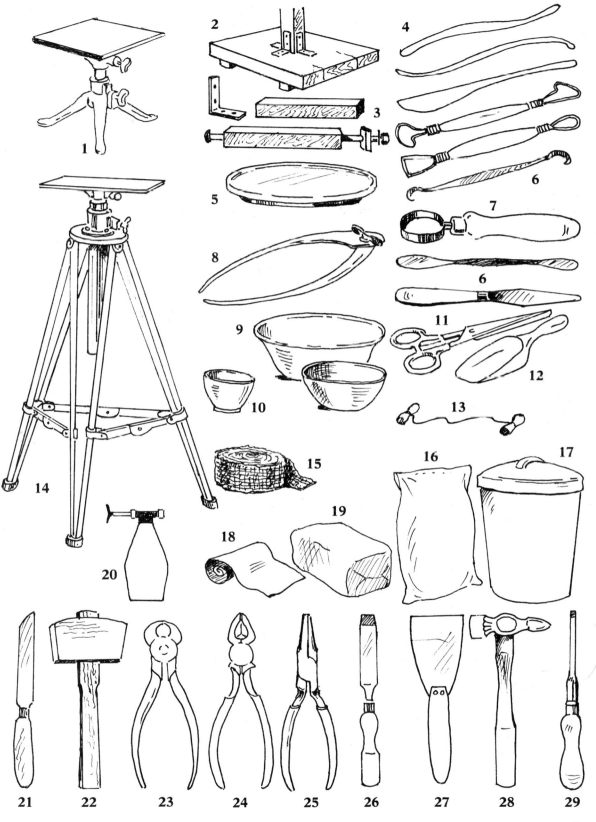

MAKING ARMATURES

An armature is a support on which a model can be fashioned. Making an armature is quite easy and with a little practice, it can be made in a few minutes.

Note: The importance of constructing a sound, workman-like armature to support the model cannot be over-emphasised. Done properly, it will greatly simplify and speed up the modelling process.

First of all you will need a baseboard on which to work. The board should have two strips of wood (lifting bars) attached underneath. These will facilitate lifting the model. Next, for a figure, you will need an iron armature support that can be attached to the board either in a corner or on one side; for a portrait, you will need a wooden 'peg' (see p. 16) fixed to the board with a long bolt or angle brackets.

For making an armature, some square aluminium armature wire sold by sculptors suppliers (see list on p. 127) is excellent. Otherwise, you can use some soft wire, two or three strands twisted together, in long lengths which can be cut as needed.

Form the armature by twisting and binding the wire as shown in the illustrations. In figure work, complete the figure before binding it to the iron support, and make sure that the legs are well clear of the baseboard. This will allow for adjustments in height.

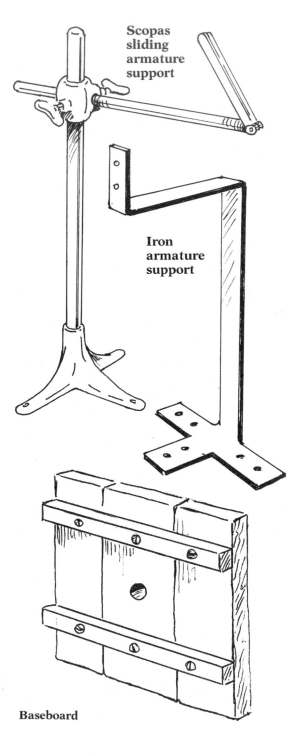

Scopas sliding armature support

Iron armature support

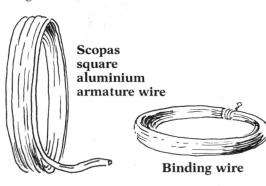

Scopas square aluminium armature wire

Binding wire

Baseboard

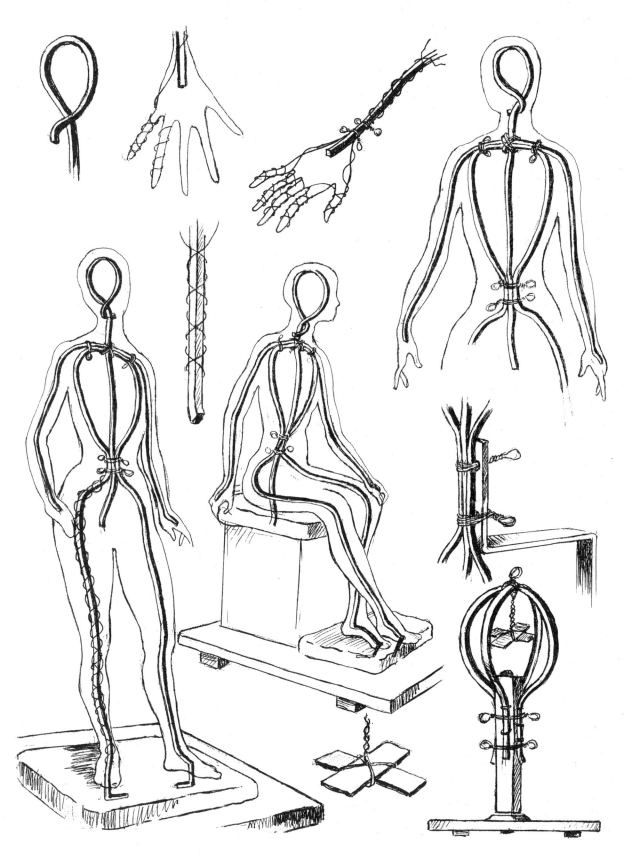

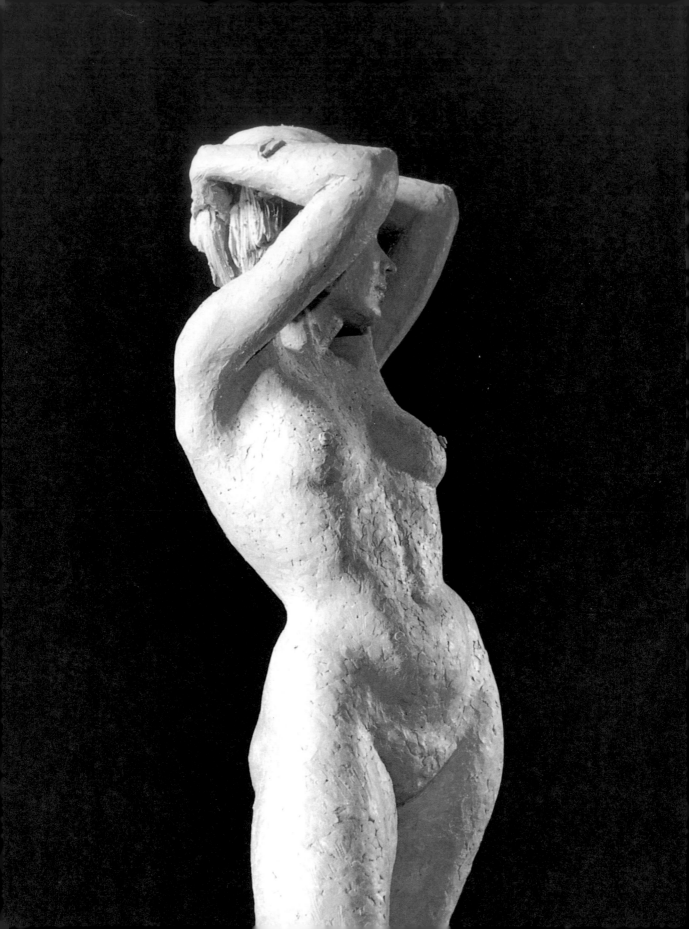

Modelling in Clay

Modelling a
Child's Head

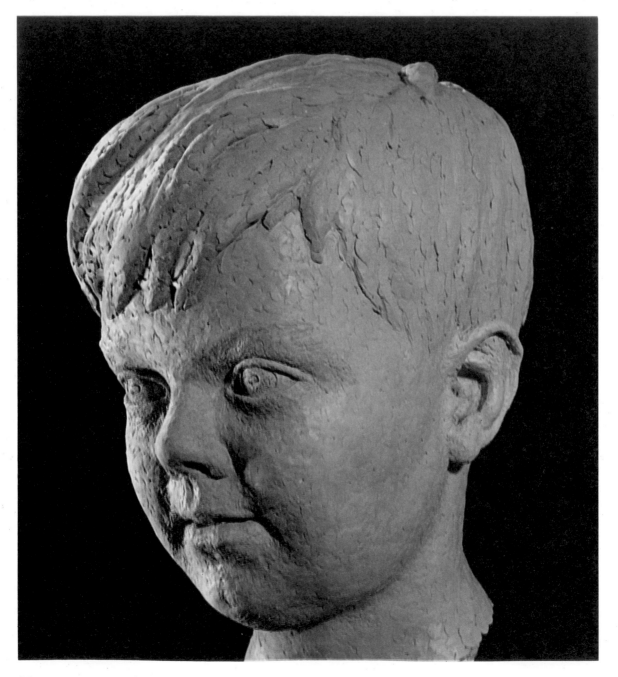

STARTING A
CLAY PORTRAIT

Modelling a portrait of a young child is, without doubt, an inspiring experience. Sculptors who have modelled children will agree that they are one of the most rewarding subjects if also one of the most difficult.

Some preliminary sketches

When your model arrives, do not immediately start working with the clay. You will both need time to relax. Use this time to make preliminary sketches and, with calipers, to take all the measurements you will need. Mark the measurements on your sketches of the front and side views of the head. Don't forget the neck and the distance from the radial point (top of the nose level with the eyes).

Note: It is a good idea to make yourself a pair of calipers with stiff card, a wing nut and washers. (See drawing.) Calipers made from card are much kinder and safer when dealing with a young sitter. Save your metal calipers for your ruler checking.

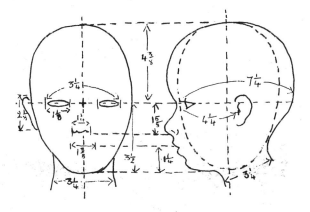

FIRST SITTING

During the first sitting there will inevitably be much time spent showing the young model all the mysteries of the studio equipment. Let him know all about everything – how the modelling stand goes round and the purpose of the modelling tools. Then give him some clay and a board to make something for himself.

Sketches

Try to make all the sketches you can during this time, and let your sitter watch you start making the armature. With all of this to break down any shyness or reserve, it is easy for the both the sculptor and the sitter to enjoy a warm, friendly cooperation and to share the whole process of modelling a portrait.

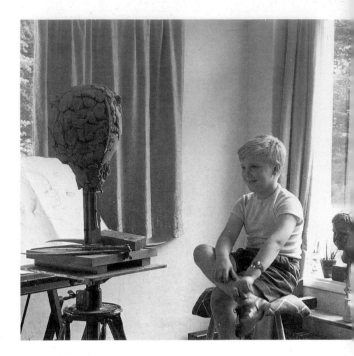

Making the armature

The armature for a portrait should be kept just within the measurements of the head. It must be firm because the weight of the clay used will be considerable.

For this portrait a 10″ board with an 8″ wooden peg bolted to the centre was used. Two pieces of ¼″ square aluminium wire were looped and secured to the peg with staples. This was further strengthened by binding the stapled part with wire and also by binding the top where the looped wires cross.

The butterfly

A 'butterfly' should be made with two crossed pieces of wood bound together with wire. This should then be fixed to hang in the centre of the armature. It will help hold the bulk of the clay firmly in position. This whole armature will prevent the clay from sagging under its own weight, and it will stand up to a considerable amount of packing and building of clay.

Clay condition

The clay must all be of the same consistency – pliable but just dry enough to leave the hands clean. Roll manageable-sized pieces in the hands and steadily build up the core. It is most important that the clay should be packed very firmly and solidly together.

Blocking in the core

Pack the clay until the whole centre of the armature is solid. When the basic shape is completed, it will form a firm and steady base on which to start blocking in the portrait – the features, chin and the back of the head which needs to be built out beyond the basic shape.

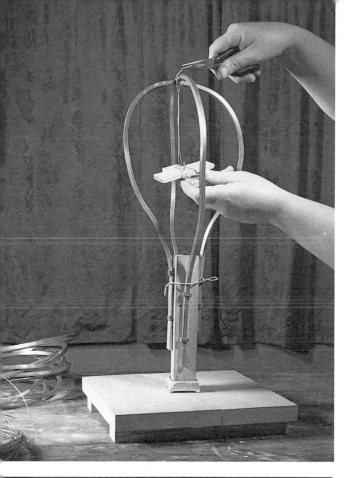
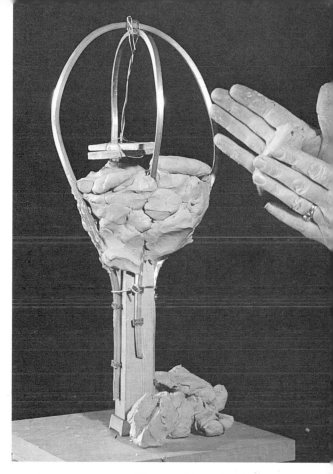
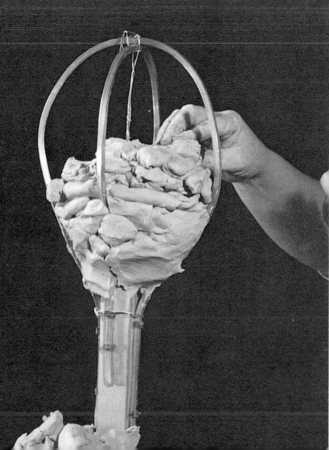
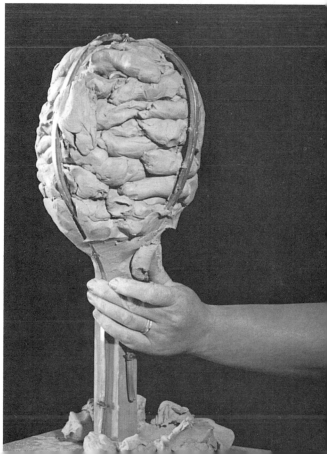

The pose

Having made rough sketches of the young model, you shouldn't find it too difficult to select his most characteristic pose. Take time at this early stage with the blocking in of the clay because it is important to have the head set in the correct position on the armature. (Note the position of the peg in relation to the 'set' of the head.)

Radial point

Begin to build up the size and shape of the skull (forgetting the hair). Find the position of the bridge of the nose and mark this point with a matchstick in the clay. This is the key, radial point from which to take all checking measurements with the calipers and it must *not* be altered. Use the main measurements of the model which you have written on your preliminary sketches.

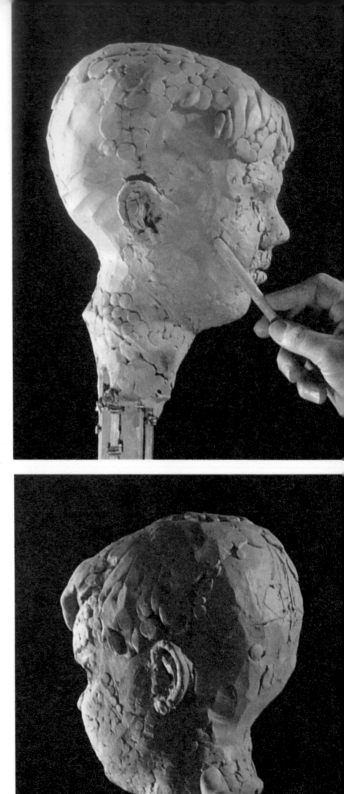

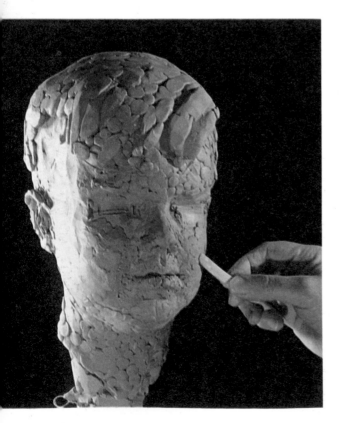

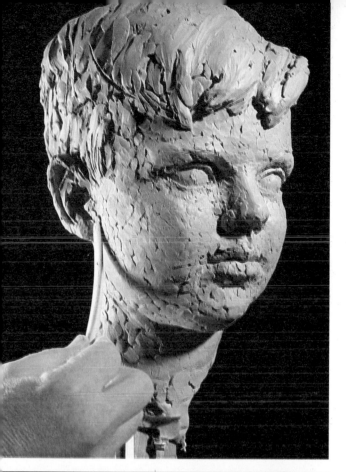

Turning

When working on the head, keep turning it so that the clay is brought to a consistent standard all the way around. Stop when you are satisfied that this has been achieved. Stand back from the portrait and observe it carefully. This would be a good time to break off so that when you come back to the next sitting you will feel confident about starting the finishing stages.

Spraying

After each sitting, finely spray the clay so that it stays in good working condition. Do not make the head too wet because this will spoil the modelling detail. Then cover the portrait with a large plastic bag, securing it tightly at the base to exclude any air. This will keep the clay in good condition for a long time.

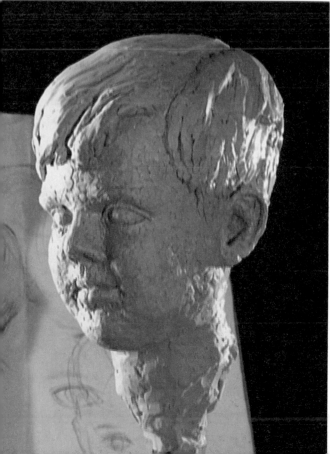

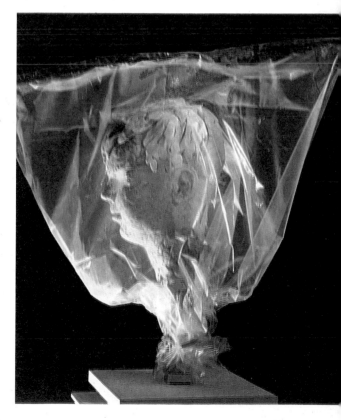

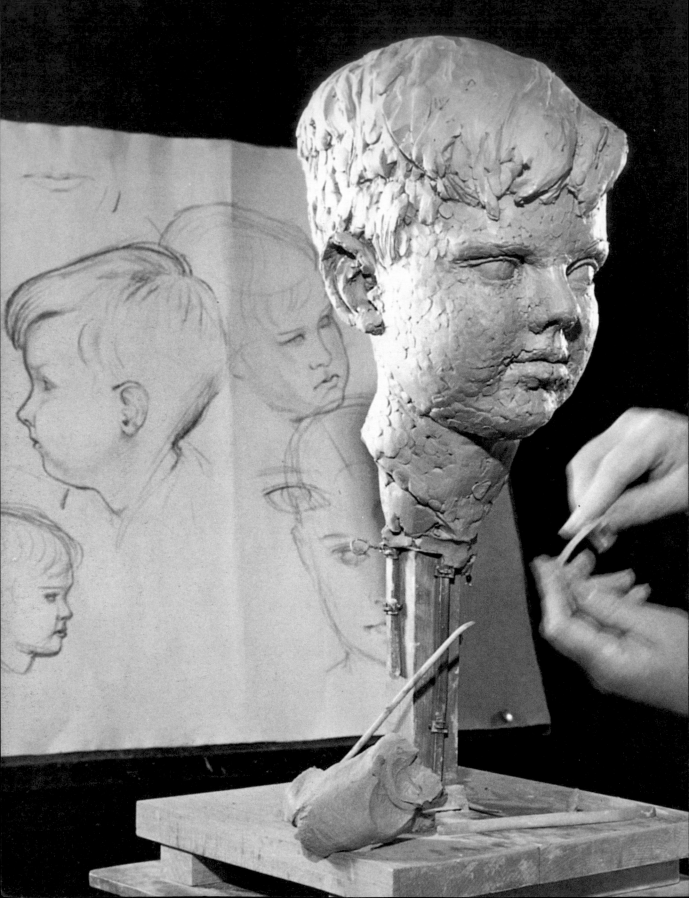

Progress

It can be seen how the progressive stages of the portrait have developed from the first blocking in when it was so important to have the basic constructions correct and the broader masses of the head accurately observed.

True form

Gradually the portrait has become a true likeness as the full rich forms have been brought to finer and finer stages. This likeness is only obtained by observing and modelling the form. The delicate but rather heavy features of this very boyish head have already been successfully achieved.

The neck

The neck has been made tidy and ready for moulding. The outward turn at the base has not been missed. This is most important to the appearance when the head is mounted for presentation.

Finishing

It can now be seen clearly how, by bringing the standard of modelling up in consistent stages all around, the modelling has been kept in control at each sitting.

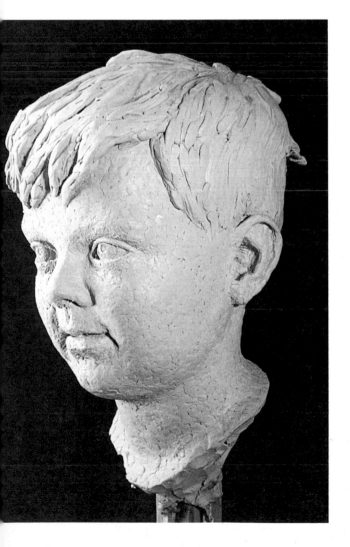

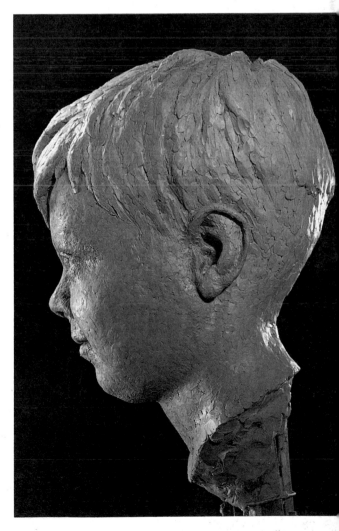

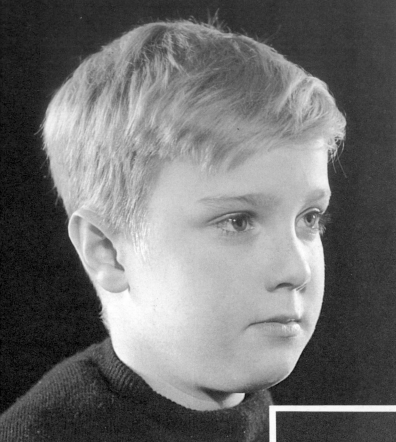

Detail

Here the details of the portrait show how the modelling has been brought up to a sufficiently high standard that it can be considered complete. The forms are well related; subtle pieces around the corners of the mouth and the little 'pull' below the nose show up well in these photographs. Also, the full chin has become delicately alive and fleshlike. This is achieved, not by any smoothing or 'surfacing', but simply by carefully observed forms gently flowing one into the other. The pleasant, varied texture simply shows a stage of modelling which could, if desired, be taken even further.

Comparing

Whenever a live model is available for sitting, it is wiser not to try to make use of photographs. This portrait was not touched without the boy's presence; the photograph has only been included for interest and comparison.

Now the portrait is ready for moulding. The clay should be kept in a good working condition (see p. 19).

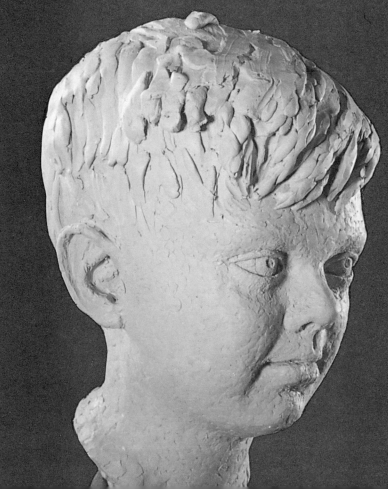

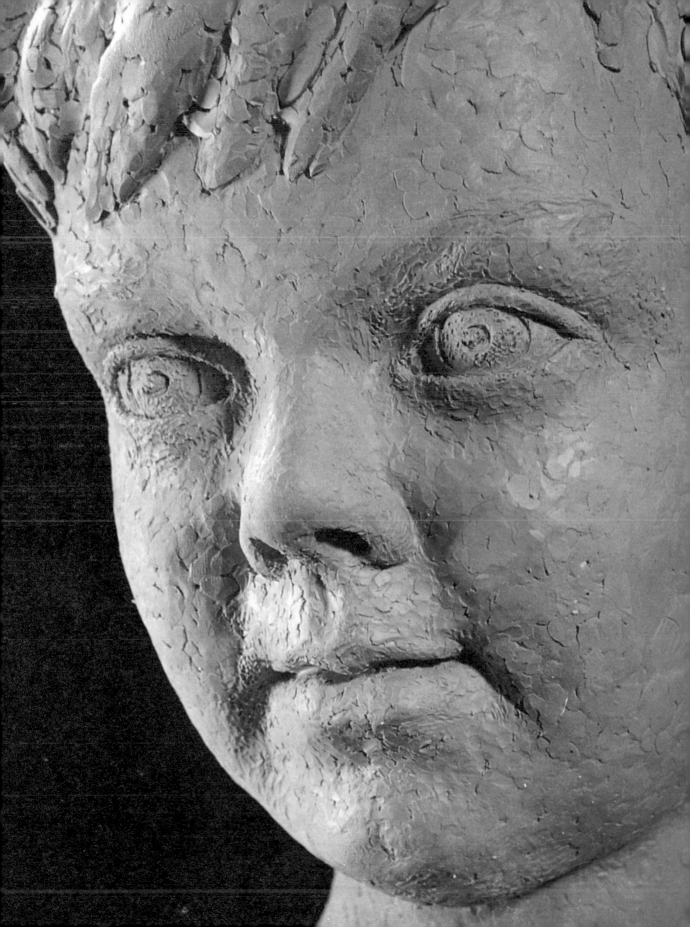

MOULD MAKING

Although many sculptors have their work professionally moulded and cast, there is no reason why even a beginner should not have the satisfaction of moulding and casting his own work in plaster of Paris. By obeying the simple rules for handling this most manageable and sympathetic of materials, the sculptor will soon get the 'feel' of plaster mixing. It is a process which should hold no fears for the sculptor. (Moulds can be made from other materials – see notes on pp. 116–18.)

Plaster of Paris

Plaster of Paris for sculptors' use in moulding and casting must be Superfine casting plaster or Dental plaster. This can be obtained from some potteries or it can be specially ordered through builders merchants. (Building plaster is useless for moulding.)

Plaster of Paris must be kept DRY. Never put a damp hand into the main bag as this can 'send off' the whole batch which will result in weak moulds. Care should also be taken not to splash any water near the main bag for the same reason.

Always test the plaster to make sure that it is good. If it is good, when the plaster is mixed and allowed to harden, it should break crisply or snap but it should not crumble.

Plaster will not harm the skin though it can be a little drying. The use of hand cream when you are finished will remedy this. Otherwise, you could use a barrier cream before starting the process.

Mixing

To mix the plaster, use a clean plastic basin with clean water. Always sprinkle the plaster into water, continuing until the plaster settles on top of the water. If you look carefully you will see the surface sucking down or 'working'. As this action begins to stop, mix the plaster gently with your hand. When the plaster feels smooth and even, it is ready for use. Use it at once. Never con-

tinue using plaster that has turned thick and lost its creamy quality.

Materials and tools

Plaster of Paris	Superfine white casting plaster or Dental plaster
Bowls	Plastic, soft as possible in variable sizes
Scrim	Jute scrim (obtained from builders merchants in rolls)
Shim or fencing	Brass sold in rolls or by sheet
Square armature wire/Binding wire	For putting moulds together
Soft soap	Obtainable in jars from chemist shops
Olive oil	For sealing moulds
Clay	For making clay bands
Clay slip	Clay of a creamy consistency (keep in lidded jars)
Tempera colour or Bluebag	For very slightly colouring first coat of plaster

Knife, mallet, pinchers, hammer, pliers, scissors, brushes, rolling pin, plastic sheeting

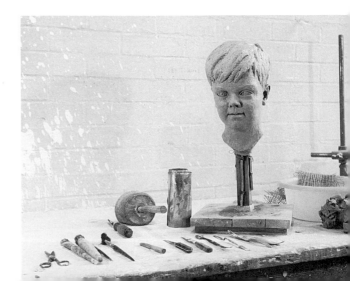

Testing

It would be unwise to make a first mould from a model upon which much time had been spent without first making some tests and becoming familiar with the process of mixing plaster and mould preparation. An useful exercise is to first make a simple, one-piece mould.

1 Put a simple piece of modelling, or just a piece of clay, on to a board that has been covered in clay slip. Then put a clay band around the modelling.

2 Mix the first coat of plaster with just a touch of colour in the water. Make just enough plaster for a thin coat. When set, give the first coat a few touches of clay slip. This will assist in the chipping out later.

3 Mix a second coat of plaster without any colour. Put this over the dried first coat.

4 Cover the second coat of plaster with pieces of scrim that have been wetted and dipped in plaster. (This will give it strength.)

5 Plaster gets quite hot when it is drying. When the mould is dry, remove the clay band and lift the mould from the board. Wash the clay out of the mould. Water will not hurt it.

6 Seal the mould by working some soft soap into the mould with a brush. Wipe it out and repeat the process. A coating of oil can be put in the mould after the soaping to further seal it if you wish.

7 For the cast, mix enough plaster to coat the inside of the mould. Unless the mould is very small, do not fill it solid, but instead lay a second coat of plaster with scrim into the mould. Aim for an even thickness in the mould.

8 When the plaster has set, use a chisel and mallet to chip away the mould down to the coloured first coat. Then, more carefully, chip the coloured first coat away from the cast. Use a metal tool to pick out the last bits.

When you feel confident about making a single mould, make a two-piece mould using either the shim seam or clay band

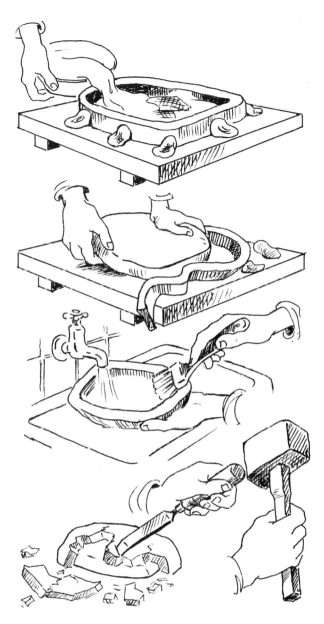

method (see p. 26). Each artist will develop his own preference as to where to position seams and you will often find that you have one 'master' mould piece with one or more smaller pieces to go with it.

Before beginning, put a good clay wash over the whole board. This will help when later removing the figure from the board. It is also a good idea to put a thick ring of clay around any iron supports. It is sometimes helpful to lay a band of clay around the base of the modelling to the thickness of the mould required.

Shimming for moulding

Shim is brass that is sold in rolls or sheets. Cut equal-sized pieces of shim and press them into the clay as illustrated. Always make sure that the edges of the shims are smooth. Trim them if necessary. You will sometimes need to make wedge-shaped pieces. Bend some of the shim pieces into 'keys' or 'locks'. These will ensure a perfect fit when you assemble the mould pieces. With the shimming method, plaster can be put all over the model at one go thereby allowing the mould pieces all to be made at the same time.

Clay band method

In the clay band method, each mould piece is completed separately. To use this method, first roll out some clay and cut it into strips which will form the band. Apply the band to the position of the seams. Place clingfilm over the parts not to be plastered. Apply the plaster to the master mould. When dry, remove the band and clay slip the edges of the plaster seam (take some clay over the edge of the seam and mould). Then proceed with the next piece of mould. Clean the seams down with a knife.

MOULDING CHARLES' HEAD

Preparation for a two-piece mould

Keep the clay in a moist, working condition. Decide on the seam line for making a two-piece mould. (I find having the seam in front of the ears makes for easier casting later on.)

Put a roll of clay under the base of the neck. This will prevent the plaster from running down and off the upright subject.

Shimming

Cut the shims into convenient pieces. You will find that you will need some wedge-shaped pieces.

Insert the shims firmly into the clay.

Remember to make some 'keys' which will help when putting the moulds together later on.

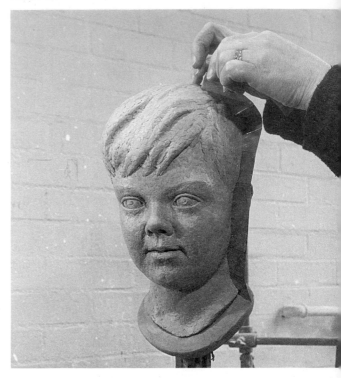

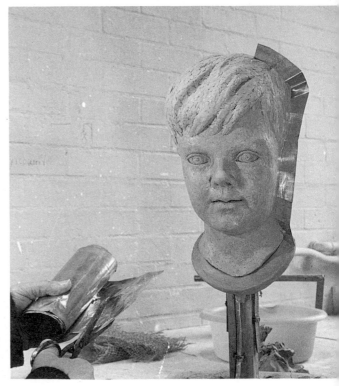

First plaster

Prepare the work area. Then mix the plaster and add a slight touch of colour to it. Whilst still freshly mixed, flick the plaster up onto the clay. This will enable the plaster to reach important crevices. This first coat of plaster need only just cover the clay. When the plaster becomes a bit firmer, build up the plaster around the shims to a thickness of $\frac{1}{4}''$ to $\frac{1}{2}''$. Be careful not to disturb the shims. Keep the shim edges clean if possible but sometimes it is better to finish the second coat and then scrape them down.

Clay slip

When the coloured plaster is dry enough, brush some clay slip over parts of the plaster. This will ease the chipping out stage later on. Do not completely slip the head; the second coat of plaster will adhere to the unslipped places.

Cleaning the seam

While the plaster is still slightly soft, clean the thickened seam down to the shim edge. If the plaster has dried quickly, it may be better to leave the seams until after the second coat of plaster.

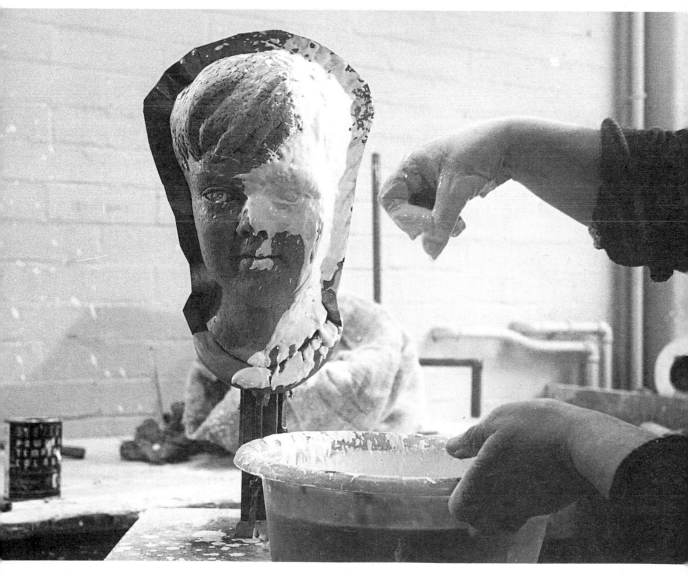

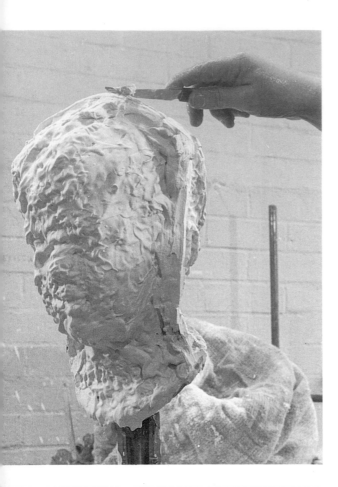

Second plaster

Mix the second coat of plaster, this time without colour. Apply a thin coating of plaster. Strengthen the plaster by applying scrim which has been previously wetted and dipped in plaster. Spread the scrim flat but make sure that it does not cover the seams. Apply the rest of the plaster keeping the thickness of the mould as even as possible over the contours of the head.

Cleaning the seam again

With a knife, clean down the seam to the edge of the shim and then leave the mould to mature for several hours. The plaster will get quite warm as it sets.

Removing from the board

When the plaster is hard, remove the head from the board. This head was secured with a bolt through the bottom of the board. It had to be unbolted before it could be moved. If angle brackets have been used, then you will need to clean off the plaster at the base and unscrew the brackets before you can move the head. (See also p. 47.)

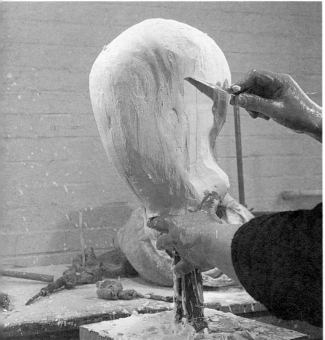

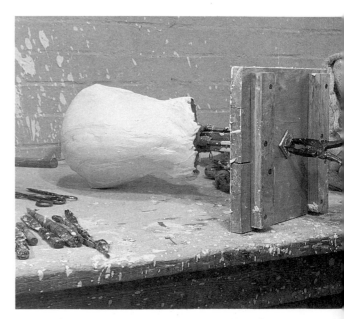

Soaking

Soak the mould in water. The swelling clay will push open the mould.

Separating the moulds

The front mould should easily lift away from the clay, leaving the armature and peg in the back of the mould. Care must be taken not to damage the inside of the mould by roughly removing the armature. Lift the soaked mould onto the bench.

Removing clay

Free clay from around the armature. Clip out the butterfly. If necessary, bend or cut the armature until it can be easily lifted from the mould. Now, thoroughly wash the moulds. The last traces of clay can be removed with a small wooden tool or an orange stick.

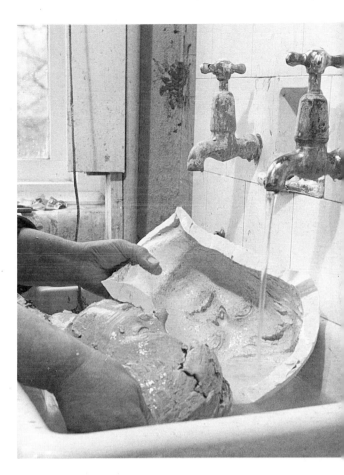

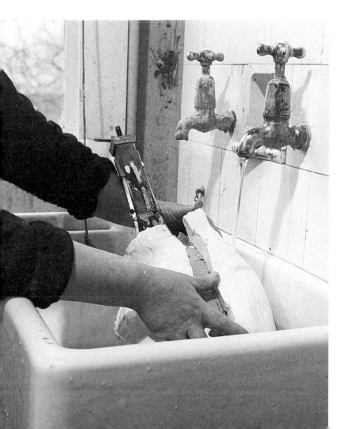

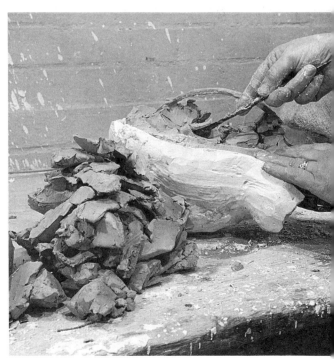

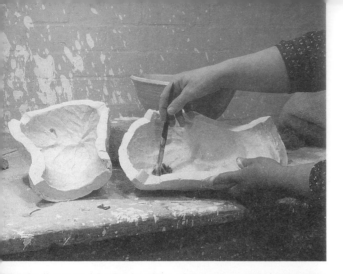

CASTING

Soaping and oiling

The moulds must now be sealed on the inside to prevent the plaster cast filling adhering to the moulds. There are many ways of sealing including some sprays. However, a traditional way which is very effective is as follows: Using a soft brush, work some soft green soap into the mould. Clean off any froth with a brush and then give the mould another coat of soap. When the soap is well soaked in, wipe off any excess and give the mould a thin coating of olive oil. Treat the edges and seams also.

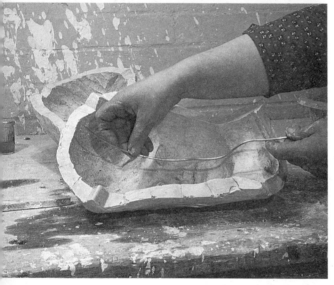

Shaping metal

Take a piece of fairly hard metal and bend it to the shape of the mould. This will later be inserted into the cast with the second filling of plaster and scrim to give strength to the cast.

First plaster

Mix the plaster (separately for each piece) for the first filling. Pour the plaster into the mould and swill it around to give an even coating. Do not let the plaster become over-thick in the hollows. Pour off the surplus and clean the edges.

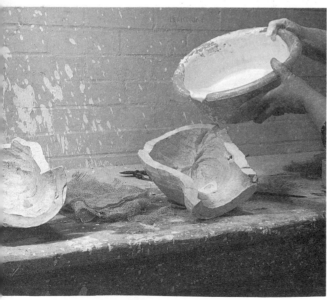

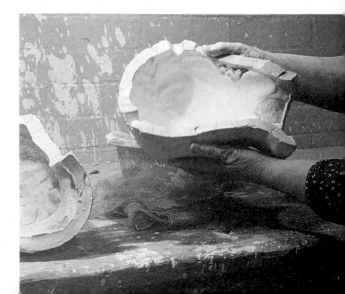

Adding metal

When set, tip in the shaped strengthening metal and use a few blobs of plaster to hold it in place.

Second plaster with scrim

Mix a second coat of plaster and spread a thin layer of it onto the first layer. Using the same mix, put a layer of plastered pieces of scrim evenly over the inside of the mould. Clean off the edges and make sure that no scrim obstructs the close locking of the pieces.

Assembling the mould

Assemble the mould pieces making sure with the help of the keys that the fit is clean and tight. Then tie the pieces together with wire or cord. It is often a good idea to wrap a few pieces of lightly plastered scrim over the wire to prevent it from slipping.

Filling the seams

Mix some new plaster and pour it into the assembled mould. Swill the plaster around well so that it fills the seams. Pour off the excess plaster.

Strengthening with scrim

Lay pieces of plastered scrim inside over the seams. Use a tool or stick to reach difficult areas. Add an extra strengthening layer inside the neck. Leave the mould to mature.

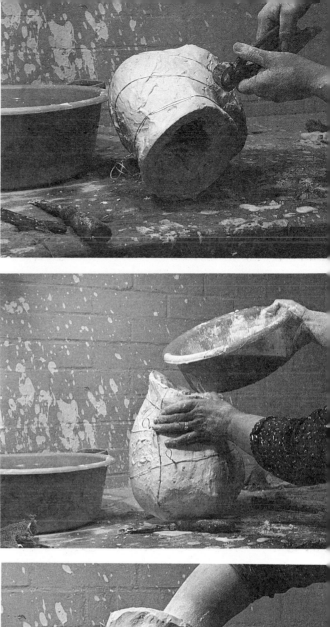

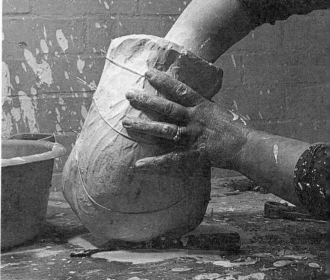

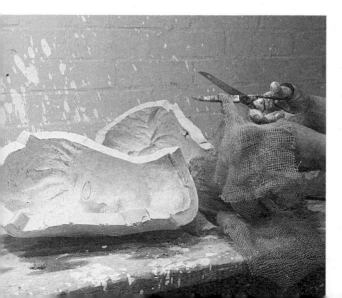

Chipping out

When the mould and cast have dried out, support the head on a soft bit of sacking or an old cushion. With a wooden mallet and a blunt chisel, proceed to carefully chip the mould from the cast. The thin coloured first layer of plaster will warn you that the chisel is close to the cast. Carefully remove this coloured layer.

Picking out

Pick out any mould plaster that locks into crevices with a metal tool. If there is any damage, wet the area and repair it with a little fairly thin plaster.

MOUNTING

Mounting bar

Cut a piece of ¼″ copper pipe long enough to reach the top of the head with enough protruding from the bottom of the neck to insert into a mounting block. Wrap scrim that has been dipped into plaster around the top of this bar. After wetting the inside of the cast at the top of the head, push the bar with the plastered scrim up to the top.

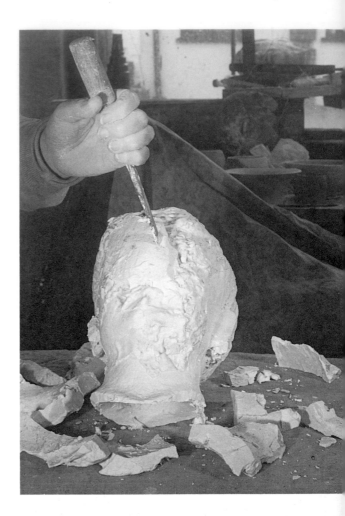

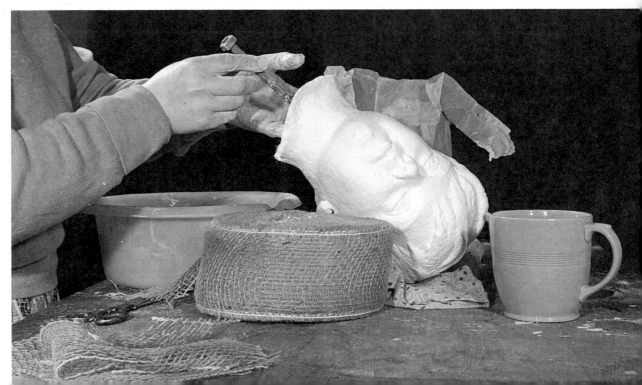

(The plastered scrim should dry and hold the bar in place.) Hold or wedge the bar close to the front centre of the neck and fix with plastered scrim. Leave it to set hard. When the plastered scrim has dried and the bar is in place, the head will be ready for mounting.

The mounting bar is unlikely to be at the correct angle. Judge this carefully by holding the head with the bar against the side of the mounting block (a block of hard wood such as mahogany would be suitable for this) and mark the angle with chalk as a guide.

Drilling

Drill the hole at the correct angle and in the correct position in the mounting block. Make the hole slightly deeper and slightly larger than the mounting bar.

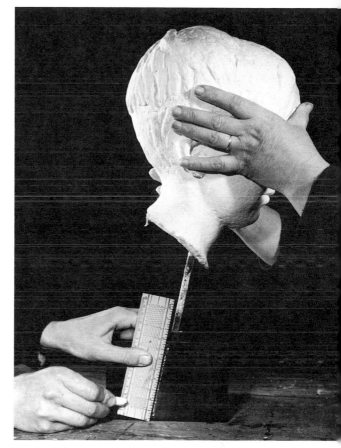

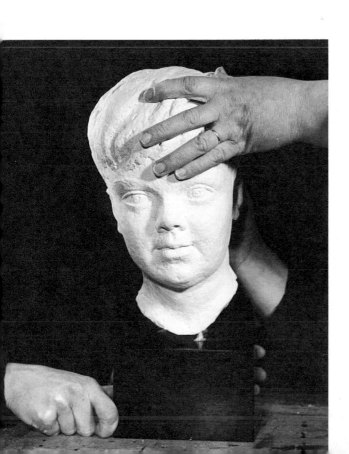

Mounting the portrait

Test that the portrait sits pleasingly on the mounting block. Alter the hole if necessary. Put some glue into the hole and, if the hole is too large, pack something like an open weave bandage or some scrim around the bar and then fit the bar into the drilled hole.

A mounting bar fixed close at the front of the neck gives a light and free appearance to the portrait.

Finally, a piece of felt or baize should be glued to the bottom of the mounting block to keep it from sliding.

FINAL FINISHING
AND MOCK BRONZING

Now that the sculpture is successfully modelled, moulded and cast, and mounted on a wooden block of complementary size, all that there is left to do is to treat the white plaster of Paris which is far too dazzling white to be kind to the modelling.

Mock bronzing is perhaps the best choice for finishing off the piece. There are many different ways to achieve this, most with good results. By far the simplest one I have found is the following. It leaves no thick coating which could fill in the finer modelling texture.

With ordinary thinned emulsion paint of dark brown with a hint of green added, give the cast one thin coat to kill the white of the plaster. When this is dry, give it another coat of the same paint. This should be sufficient for the effect you want.

Note: It is a good idea to make some test pieces to be sure that you have the colour you want and that the paint provides a good cover for the cast.

When the paint is quite dry, apply a little colourless wax polish. Leave this for a while and then gently buff it to a shine. Next, with the ball of your thumb, touch the highspots of the modelling with a little powder gold or tube frame gold. It is difficult not to overdo this gilding but it is easily removed with a little wax. Sometimes a little green powder lightly brushed into the crevices can also make an attractive finish.

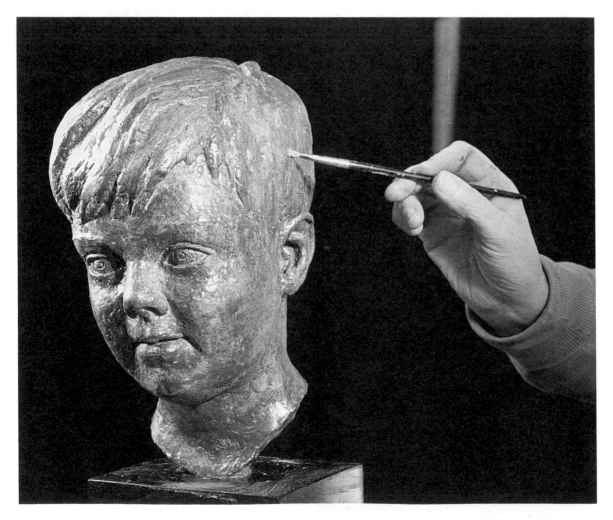

Modelling
a Torso

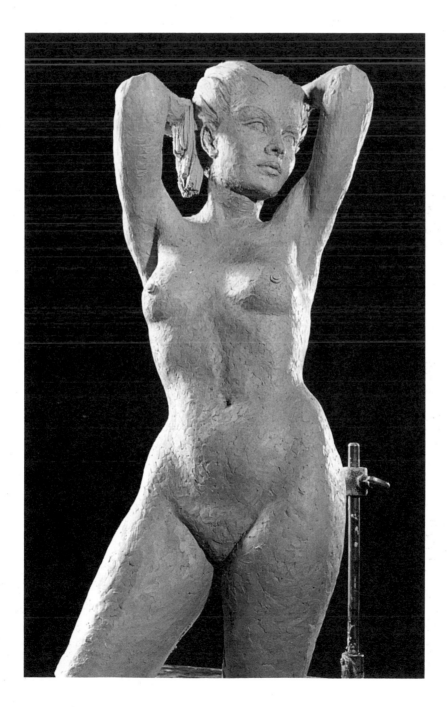

A torso is always a good sculptural subject. The severing of the legs gives the figure stability and the bulk and rich forms of the body draw one's full interest. In this study, the arms are included; as they are linked with the head, they do not break the compactness of the figure.

PREPARATION

For this small torso, you will need:

A baseboard

An armature support

A revolving stand (a domestic cake icing stand would serve well)

Some aluminium armature wire (or some twisted wire lengths)

Binding wire

Some potter's clay (½ cwt)

A plastic bag

A small water spray

Screws, screwdriver, wire cutters and a small hacksaw

First of all, sketches should be made of the subject and the size of the model decided upon.

For this torso, use a 12″ board and an adjustable metal support. Make an armature from ³⁄₁₆″ square aluminium armature wire: Use one piece of wire to construct the rib cage and legs. Place another piece of wire up the centre of the body and form the neck and head with it. Finally, place one piece of wire over the shoulders to form the arms. When these wires have been tightly bound together, the figure can be bent into position. This figure can then be firmly attached with double twisted binding wire to the extension bar of the support.

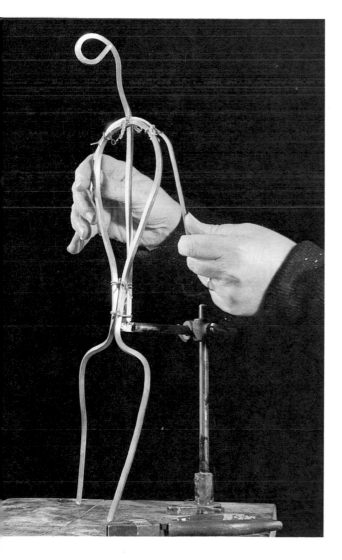

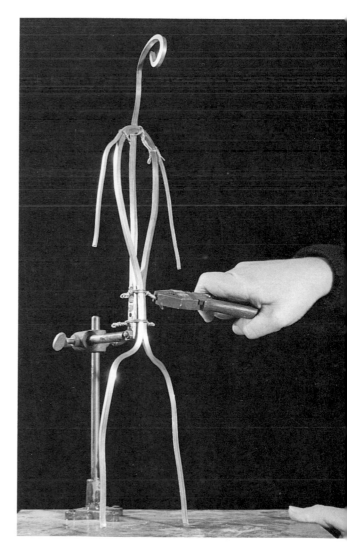

FIRST MODELLING STAGE – BLOCKING IN

Note: It is important that the clay should be in perfect condition, moist but dry enough to be pliable and clean to the fingers when modelling.

Block in the torso with broad, simple planes. The curve of the vertebral column is the key to this pose. The richly curved back, the tilt of the pelvis and the interesting thrust forward of the arms cradling the head, give the figure life and movement.

The pose

Note how in this pose the standing, supporting leg is placed leaving the right leg in a relaxed state. This could, if desired, be moved a little, either up or sideways. Later on, it will be seen that the sculptor has left the right leg free from the base thereby giving the torso a lighter appearance.

Building

Continue building up the clay with pieces of a fairly even size. Press each piece home with the ball of the thumb. The photograph shows how the clay is applied piece by piece. It should never be wiped or smoothed.

By concentrating all the time and always keeping the sculpture turning, the work will grow, stage by stage, to a consistent standard all the way around the figure. Try to refrain from finishing one part more than another. The photograph (below) illustrates well the swing of the back and the thrust of the left hip.

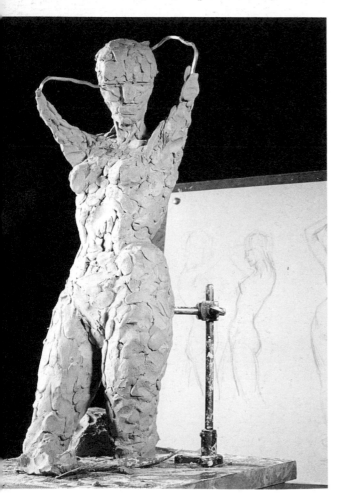

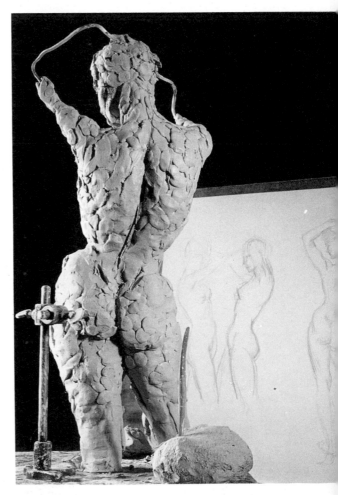

CHECKING AND THE SECOND MODELLING STAGE

After a rest, but before starting the second modelling stage, stand back from your work and, turning the sculpture, carefully observe what you have done so far. Check that the torso is correct from all angles. Now is the time to correct any discrepancy in the proportions of the figure and the pose – not at a later stage when the more detailed work of modelling has begun.

When you are satisfied with the model, continue to bring the torso, head and arms up to a consistent standard. Watch the thickness of the limbs in relation to the body, and check the angle and tilt of the head and hands. Having done this, the next stage of more detailed modelling can be enjoyed, knowing that no constructional alterations need to be made.

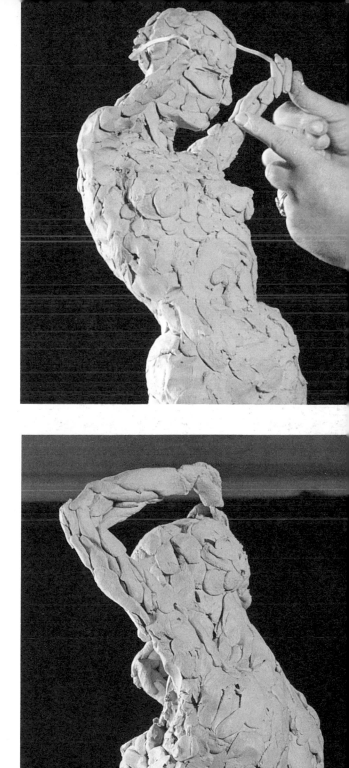

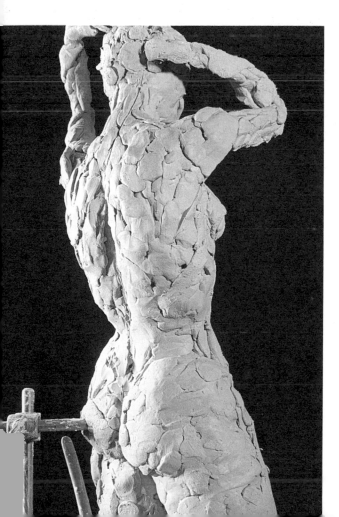

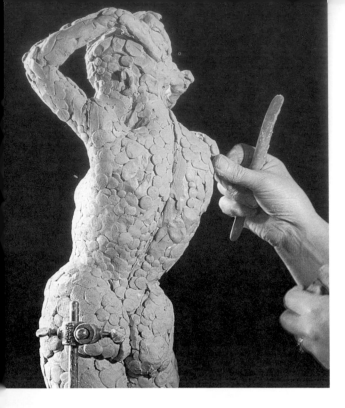

THIRD MODELLING STAGE

Now that you are satisfied that the general construction of the torso is correct, it is time to start the next stage of modelling. Check the bone structure, such as the large vertebra at the base of the neck, and the shoulder blades and the bones of the pelvis. Settle these parts before attempting more detailed form.

The modelling of the figure must always be based on gradually building up the clay. Should too much bulk be added, then use your wire tools to carve that part away. Carve well below the form and then continue by rebuilding the form afresh. When the bone structure of the rib cage and pelvis have been constructed, the modelling of the breast and the muscles that sweep up the arms can be started.

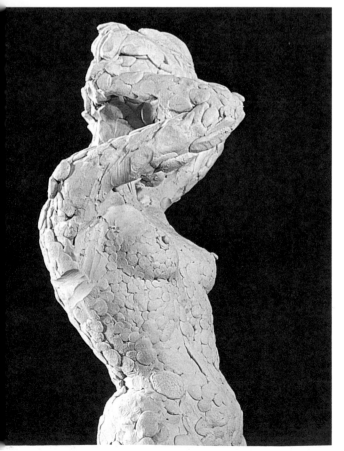

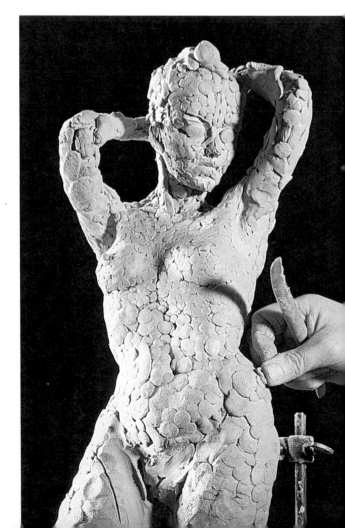

FOURTH MODELLING STAGE

The whole form of the torso should now be pulling together. In the photographs it can be seen how the modelling is coming alive as the forms are developed. At this stage the sculptor should concentrate on the correct relationship of the various forms to each other. Carefully observe such things as the strong, firm muscles on the standing leg compared with the relaxed flesh on the other. Look also at the soft, delicate form of the breasts on the harder bone of the ribs, and the stretched muscles of the abdomen.

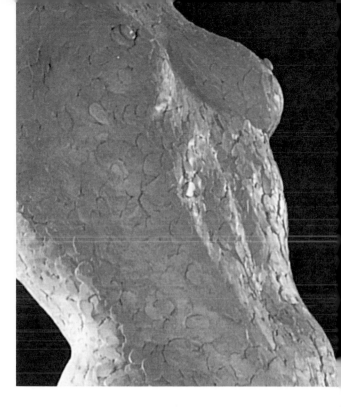

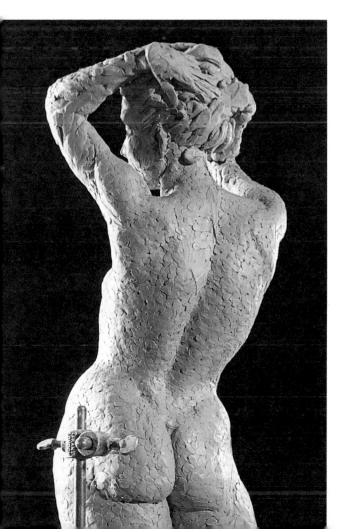

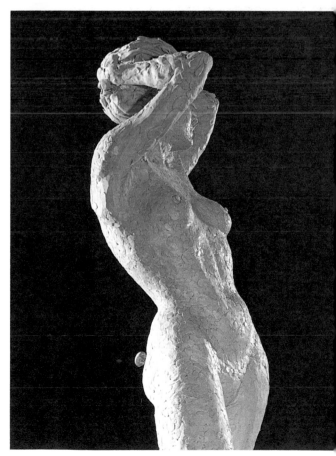

41

The head and arms

The modelling of the head and arms has so far been left a little behind the standard of the work on the rest of the figure. This is because, in this particular model, the head and arms depend so much on the more detailed development of the shoulders. In the photographs you will see that the pose of the head has been lifted a little to emphasise the thrust of the back of the head into the hands. When the position of the head is finalised, its modelling can be brought up to same stage as the rest of the torso. The figure should then be ready for the finishing stage.

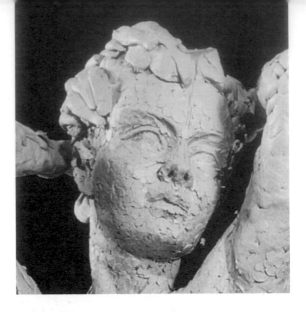

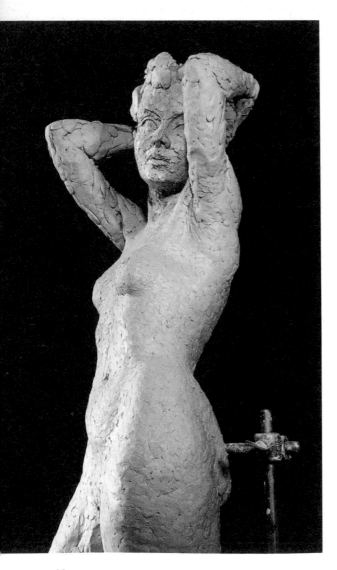

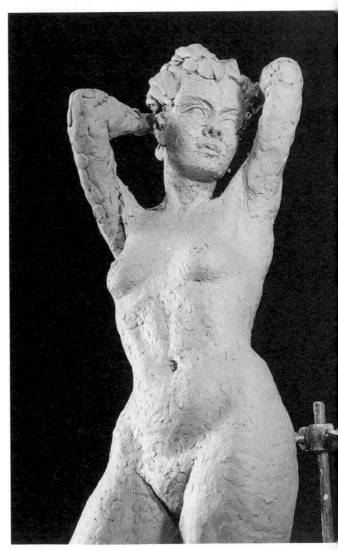

STAGE FIVE – FINISHING

The whole model should now be brought to a state of completion. The whole torso should become rich and living, with the forms flowing freely into one another. They should show that they are built over a strong bone structure with each part of the figure having its form, direction and character clearly defined. The surface of the clay should not appear to have been worked up for the sake of obtaining a 'texture', neither should it have been smoothed in any way which would give it an artificial appearance. Every tool mark left should be the result of observation only.

When you are satisfied that the model is finished, it can be used for moulding. Keep the clay in good working condition (see p. 19) until you are ready to begin moulding.

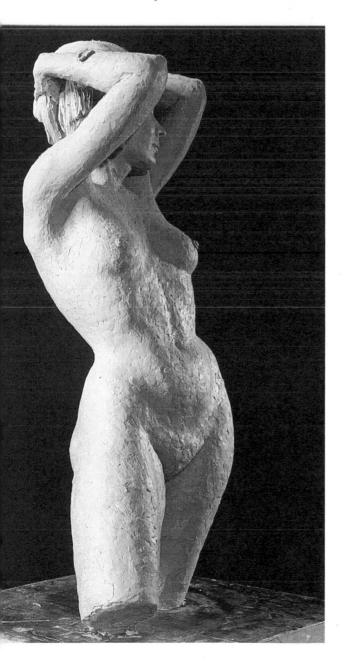

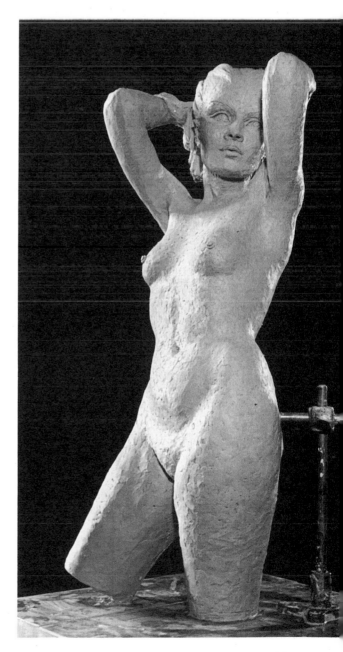

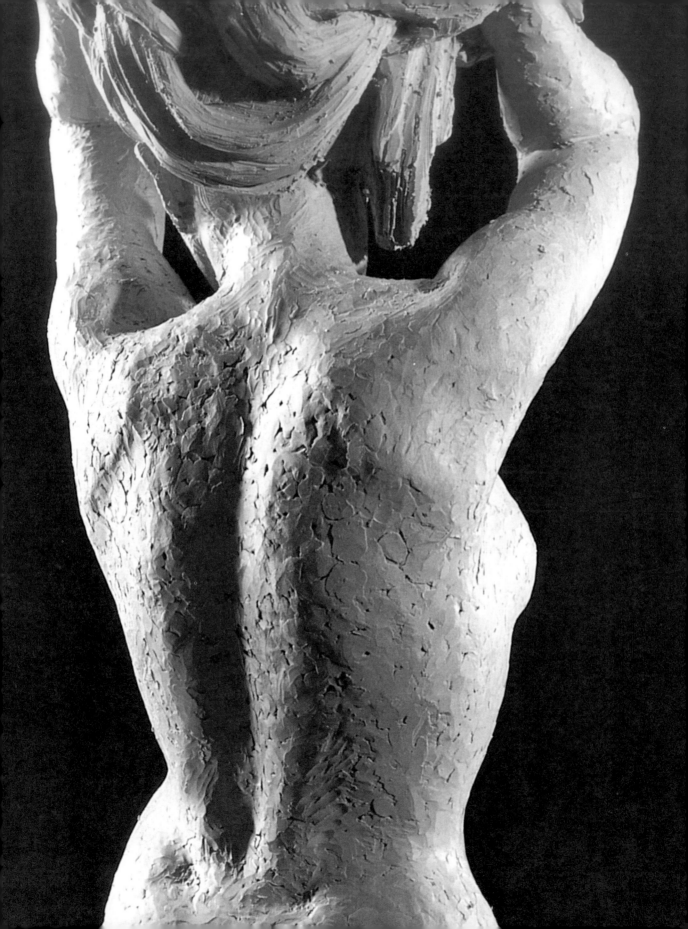

MOULD MAKING

The master mould

The back of this torso was chosen as the master mould with two separate pieces seamed across the breast. The shim method was used. The shim was placed firmly into the clay right around the body and across the breast. Some shim pieces were bent to form keys which would ensure a perfect fit of the moulds later on. (The clay band method could also have been used.)

Preparation

It is a good idea to cover the bench with a sheet of plastic and to also perhaps hang a sheet of plastic behind the work. This will help keep your work area clean. Put your tools to one side or cover them. Keep a large bucket of water nearby for cleaning your hands and bowls. This will prevent blocking sink wastes with hardening plaster. Plaster can be allowed to harden in plastic bowls; it will come off when the bowl is bent or knocked from underneath.

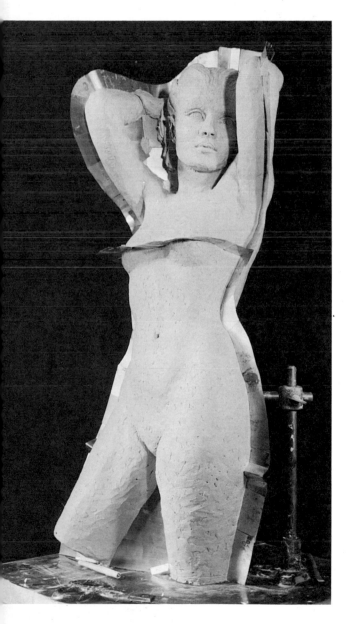

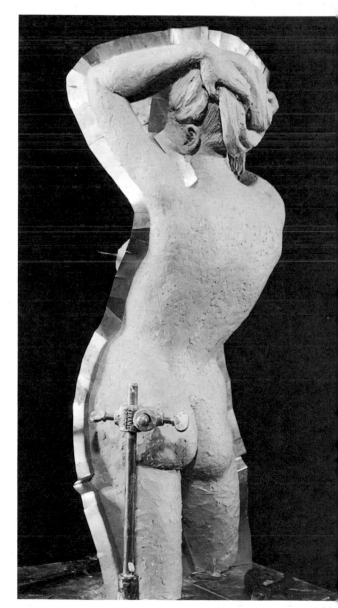

'Flicking' on the plaster of Paris

Mix the plaster of Paris as described on p. 24 and add a touch of colour to it. Cover the front of the model in clingfilm and put a thick band of clay around the iron support and the nuts. Then flick the smooth plaster on to the back of the model. The aim is to achieve a thin, all over cover. Flicking the plaster on to the clay enables the important crevices to be reached. As the plaster begins to thicken a little, gently build up the seams without in any way disturbing the shims. Keep the shim edges clean if possible. Throw out any surplus plaster as soon as it begins to get too thick to manage easily.

When the back is completely covered to an even thickness, remove the clingfilm from the front of the model and repeat the flicking process there. When that too is covered to an even thickness, it is time to wash your hands and bowls. At this point, the seams may be firm enough to clean down but it is probably safer to wait until after the second coat of plaster. You do not want to risk any movement of the shims.

Clay slip

When the plaster is dry, use a brush to partially coat the plaster with a clay slip. Do not completely coat the plaster because the slip will stop the second coat of plaster from adhering to the first coat. However, some slipped parts will make it easier to chip the mould away from the cast later on.

Second coat

Mix the second coat of plaster (this time without colour) in a clean bowl. Apply a thin coat of plaster to the first coat. Then dip little pieces of scrim into the same plaster mix and place them, spread flat, on weak parts and around the base of the figure. Be careful not to cover the seams. Do not use more scrim than necessary because it will impede the chipping out process later. Apply the rest of the plaster, keeping the thickness of the plaster over the mould as even as possible.

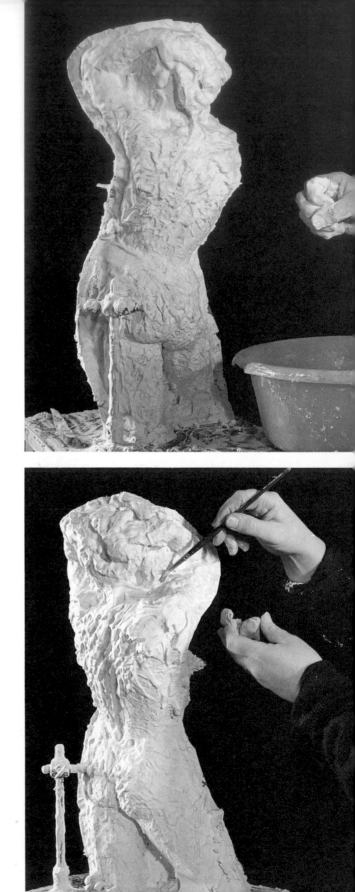

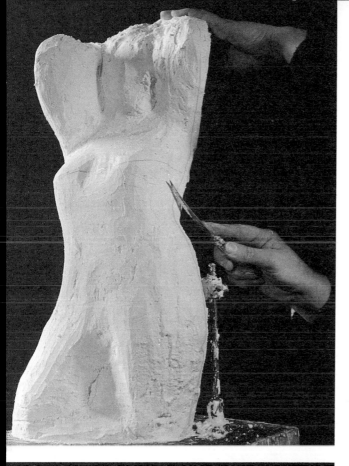

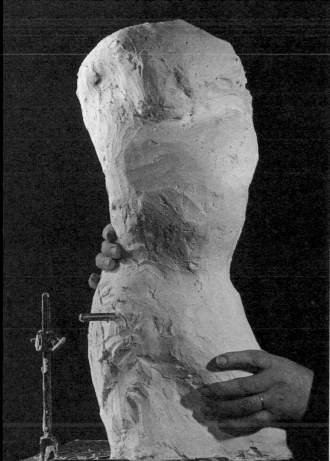

Cleaning seams

When the mould is evenly covered, clean off the seams with a knife so that the edges of the brass shims are visible. Then leave the mould for several hours so that the plaster can mature. The plaster will get quite warm as it sets.

Remove from the board

Clean clay and plaster from the supports. With the armature shown, the wing nuts were unscrewed leaving the vertical bar still in the torso and mould. Alternatively, the base of the support could be unscrewed from the board. Then wet the clay slipped board. The mould can then be slid forward to release the bar from the support.

Soaking

Place the mould into a sink or bath of clean water. As the clay swells, it will force open the seams. The clay around the seams will soften. With pliers, carefully pull out the shims and then gently ease the smaller moulds away from the master mould.

Remove the clay

When the mould pieces are free, lift the soaked mould onto a bench and gently remove the clay from inside. Clip out the wire armature taking care not to scratch or damage the inside of the mould. Take the time to carefully remove all traces of clay from the crevices of the mould. Small wooden tools or an orange stick are useful for this.

The mould is now completed. (If you are not going to fill the mould immediately, assemble the pieces and tie them tightly together so that they don't warp.)

CASTING FROM THE MOULD

The mould pieces must be prepared by sealing the insides so that when the plaster is poured in, it will not adhere to the sides. There are many ways to seal the moulds including modern sprays. An old traditional method which is very effective and inexpensive to do is explained below.

Soaping and oiling

With soft soap (a thick, liquid soap that is purchased in jars) and a good quality soft brush, carefully work the soap into the moulds. The soap will go frothy. Clean off the froth and repeat the soaping. Again wipe off the froth and then seal the insides with a light coating of oil. (Cooking oil or olive oil will do.) Do remember to do the seams and even a little over the outside returns of the seams.

First plaster

Mix enough plaster with a touch of colour for the first coat and then swill the plaster over the insides of the moulds. Pour off the excess plaster. (It is better to do one mould at a time so that there are no air traps on the inner surface and so that the plaster goes on as evenly as possible.) While the plaster is still wet, clean off the seams so that there will not be any problems when you later fit the moulds together.

Second coat and scrim

When the moulds are dry, give them a second coat of plaster. Use wetted pieces of scrim to strengthen weaker parts of the moulds. Be careful not to thicken narrow parts of the mould with too much scrim because it might cause a problem later on when assembling the moulds. Also, make sure that the edges of the mould pieces are clean so that there will be a tight fit when the pieces are put together.

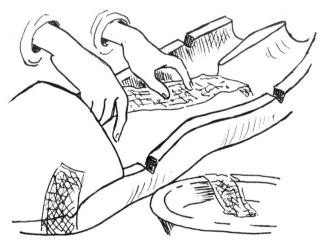

COMPLETING THE MOULD

Binding the mould

Assemble the mould pieces making sure with the help of the keys that the fit is clean and tight. Then tie the pieces together tightly with wire or cord. It is often a good idea to wrap a few pieces of lightly plastered scrim around the mould (over parts of the seams) to prevent the possibility of the cord slipping.

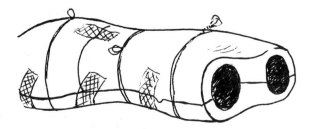

Filling the seams

Up end the mould and either prop it up or borrow another pair of hands to help. Mix up a little plaster and pour this into the bottom of the legs. Gently swill the plaster so that it fills the seams.

Pouring off

Having gently swilled the plaster around while it is still thin, pour off the excess plaster. Do not overfill the mould because the standing leg will need to be hollow to take the mounting bar later on. You should aim at obtaining as evenly hollow a mould as possible. (Only a very small mould should be solid.)

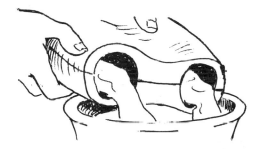

Chipping out

When the plaster has set, place the mould on some soft sacking or an old cushion. Then with one or two, not too sharp, chisels begin to chip the outer mould away from the inner cast. (The slip that you earlier put on between the plaster layers will greatly aid this.) The colour of the first plaster coat will warn you to proceed carefully as you will be approaching the precious inner cast of the model. The final bits of the mould

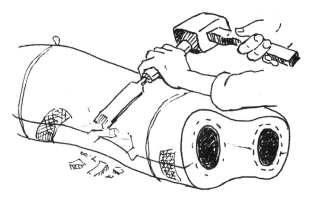

should be carefully picked away from the cast. If there is any damage, this can be repaired by putting a little weakly mixed plaster on to the wetted parts.

MOUNTING

You will now need a mounting bar. A piece of ¼" copper pipe is suitable for this. Cut a length of pipe that will be long enough to go into the standing leg and up as far as possible into the torso while also leaving enough to insert into the mounting block. (A block of a hardwood such as mahogany would be suitable for this.)

Wrap a wet, plastered piece of scrim around the top of the mounting bar. Gently push this bar to the top of the hollow cast. Then secure the bottom of the bar to the bottom of the leg. Do this by packing the leg with plastered scrim. Leave the cast until it is quite dry and the mounting bar held firmly in place. Then fix the bar into the mounting block (see p. 33).

You may also want to bronze the figure (see p. 34).

Modelling a
Ballet Dancer

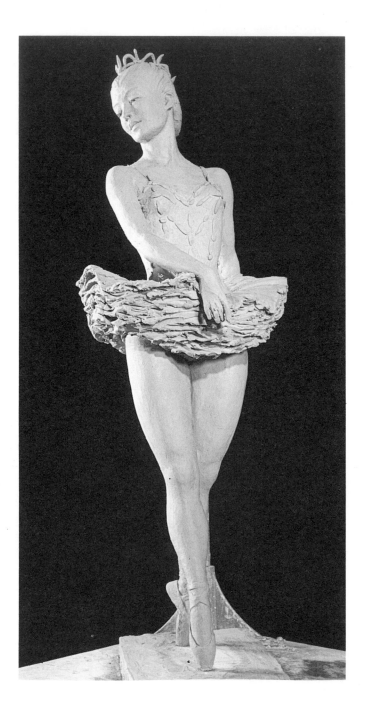

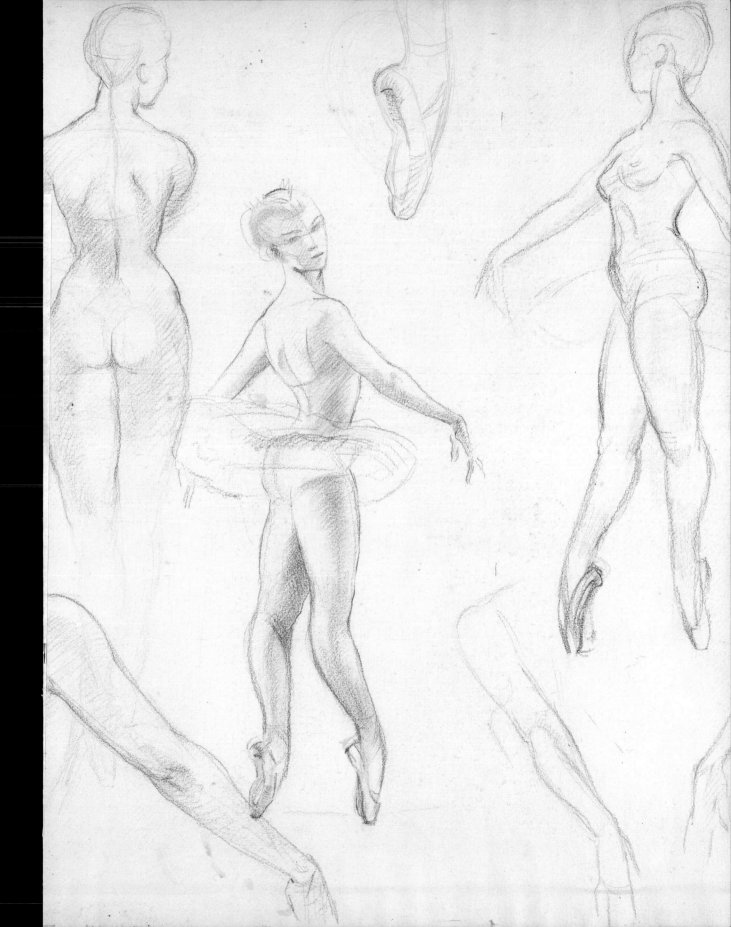

STARTING

This subject lends itself perfectly to modelling in clay. It gives the student the opportunity to show his skill and knowledge in figure work. It also calls for great observation to capture the balance and action of the pose.

After making sketches from all angles, settle on the size the clay model is to be and commence making the armature. Here a 12″ board is used; an adjustable armature support is securely fixed to it. The armature for the figure is constructed with $3/16″$ gauge aluminium wire. First, one long piece of wire is bent to form the rib cage and the waist, and then bent out again and down to form the legs. Next, an upright piece of wire with its upper end bent to the correct height for the centre of the head is attached. Then one long piece across the shoulders is used to form the arms. Finally, a piece of wire is used to form the ballet skirt. The armature is then secured to the extension bar of the support with double wire that has been looped around both legs and then twisted

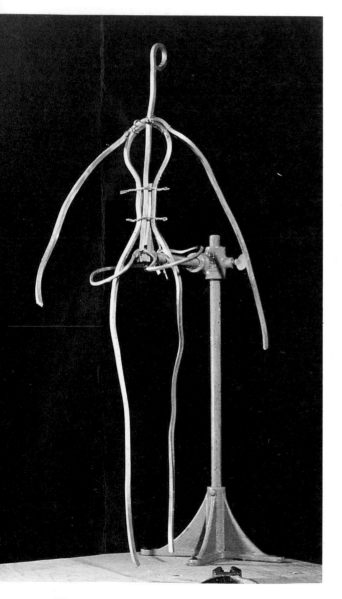

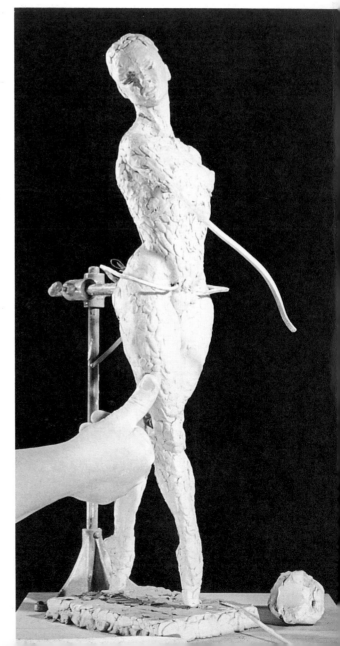

52

firmly with pliers. The armature made in this way is easily bent into the correct position and yet, with the addition of the clay, it will stay firm and steady throughout the modelling.

FIRST STAGE

Make sure that the clay is in perfect condition, just moist enough for easy working, whilst leaving the fingers quite clean when modelling. Build up the clay, pressing firmly with the ball of the thumb. Block in the figure as a nude to ensure the correct construction and pose before adding the ballet skirt.

Keep the feet off the ground. Later you can build a stand of clay underneath. This will allow you to alter the length of the feet and legs later if this is found to be necessary.

When the proportions, pose and balance of the figure are satisfactory, add the ballet skirt, and bend the armature for the arms into position.

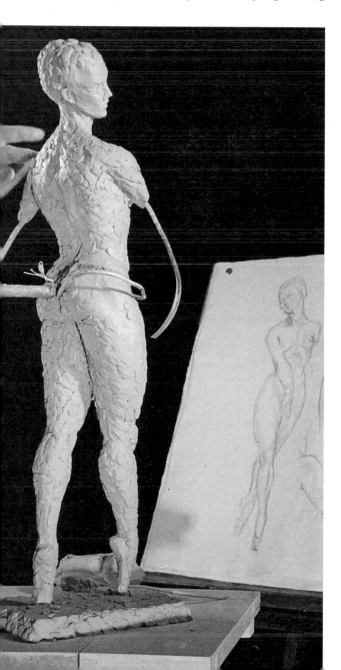

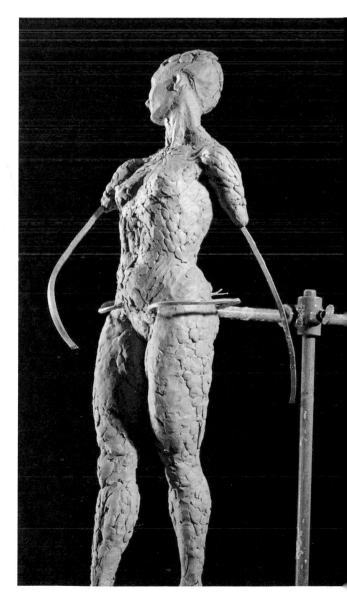

SECOND STAGE

Keep the forms as broad as possible. Bring the standard of modelling up through each stage using increasingly smaller pellets of clay. Carving should be avoided except when definite alterations are necessary. Then, carve the clay right back and slowly build up that area again.

Avoid 'finishing' any one part of the dancer more than another. Now is the time to stand back from the modelling and, turning the stand, make sure that the pose and the proportions are satisfactory and will not need any alterations. Then, bring the arms and the hands up to the standard of the rest of the dancer.

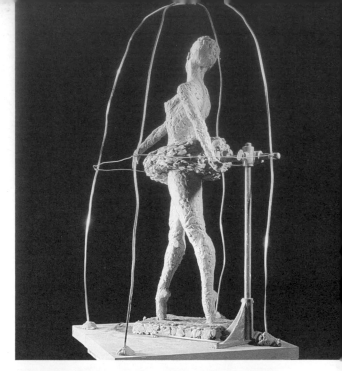

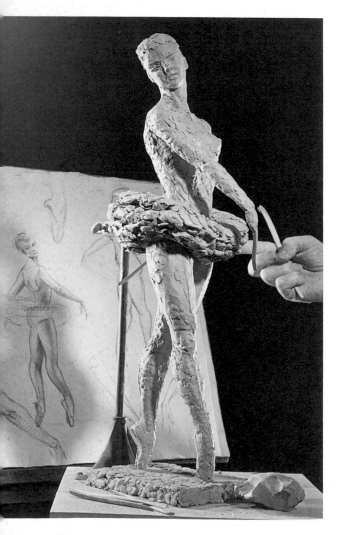

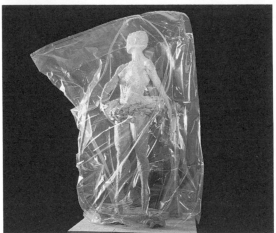

Spraying

Clay must be kept in a good working condition by lightly spraying between work sessions. Never make the clay too wet – just a moist, clean working condition. Cover the model with a plastic bag after spraying.

When the modelling begins to reach the finishing stages, it is a good idea to make an improvised cage to keep the plastic cover from touching the clay. Here two pieces of aluminium armature wire are used, secured at the top and around the middle with binding wire. The ends of the wire rest in pieces of clay on the board.

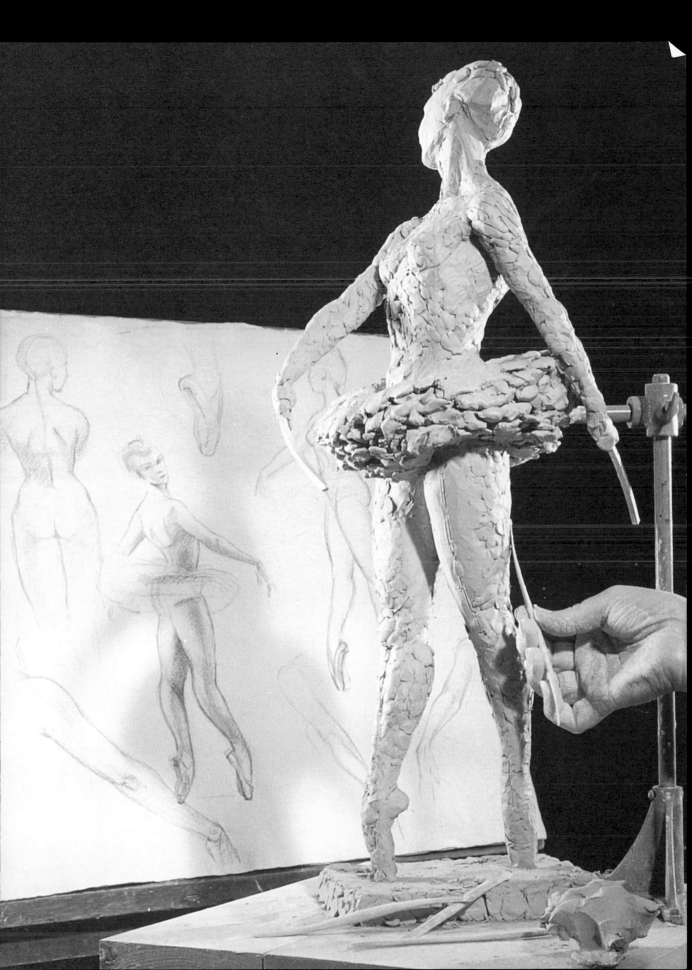

FINISHING STAGES

Here it can be seen how the modelling has been brought up to yet another, finer stage. The tighter forms flow into one another bringing more life and strength into the whole pose.

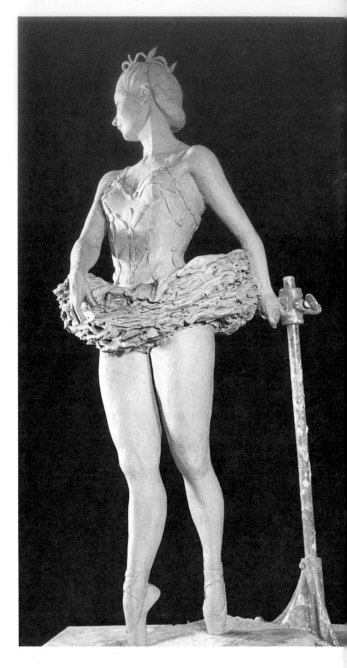

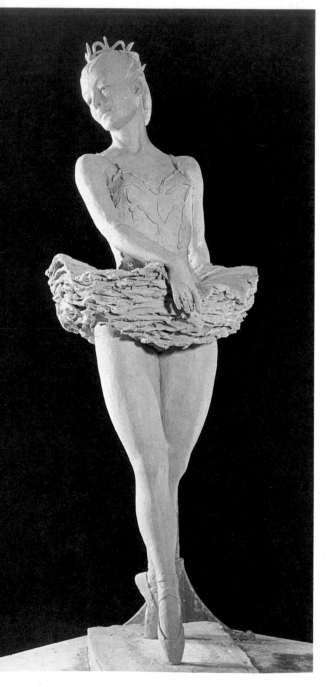

Hands and feet

The hands and feet now given more finish add much to the grace of the dancer. The feet are firmly supporting the whole figure, in contrast to the light and free hands.

Costume detail

The pleasing turn of the head is improved yet again by the light detail of the head-dress. Similarly, the detail suggested on the bodice of the costume contrasts nicely with the body.

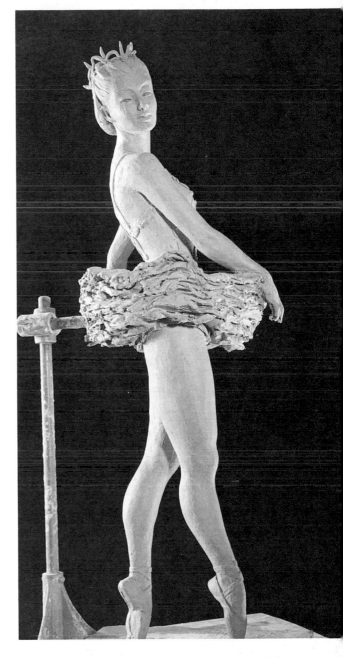

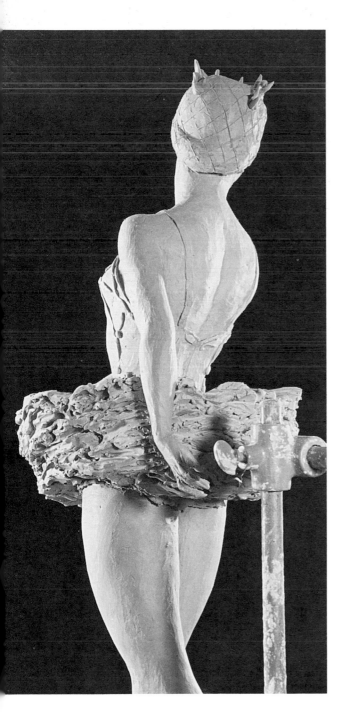

Clay finish

It is important that the surface of the modelling should not in any way be smoothed to make an 'artificial' finish. The sculptor's seeking for truth shows in the working surface of the clay and this, besides giving the modelling life, is also the sculptor's signature.

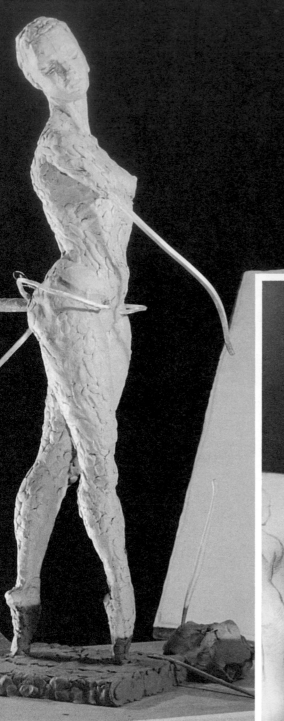

OBSERVATIONS

These three photographs taken from the same view are selected to show:

1 The important strong blocking in of the nude pose.

2 The modelling progressing to the next stage without losing the good beginning.

3 The finished dancer showing the modelling aim held in the mind of the sculptor.

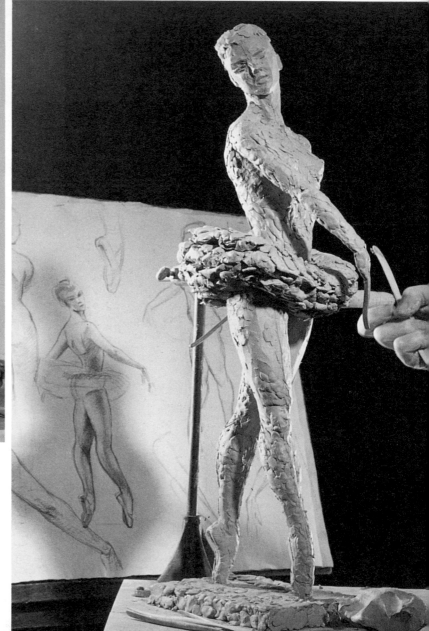

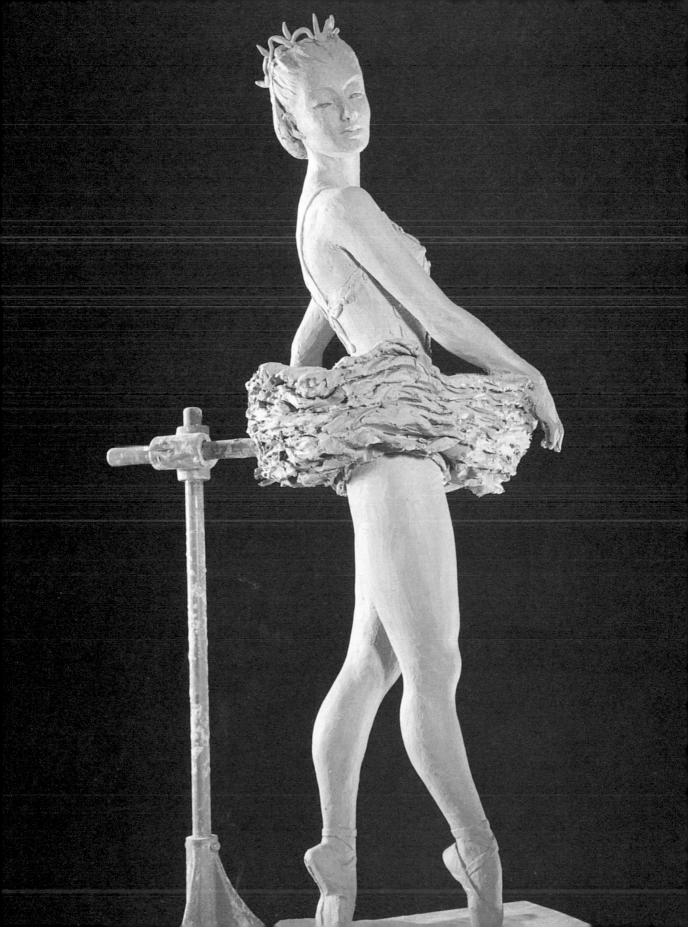

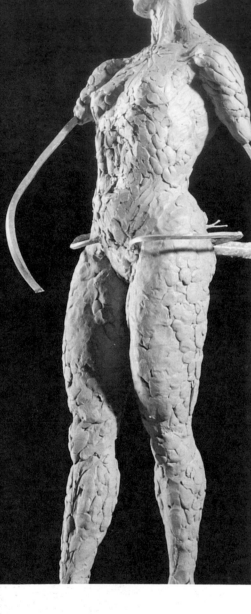

MODELLING STAGES

A further three stages of another position of the dancer. Observe how the modelling in each stage has been brought up to the same consistent standard.

The figure could be taken to yet another stage but it is as well to realise that as soon as the subtler forms are blended and the sculptor can no longer find obvious forms to be completed, then it is time to be satisfied and to cease modelling. Taking the work beyond this point is likely to result in the sculpture losing its truth and life.

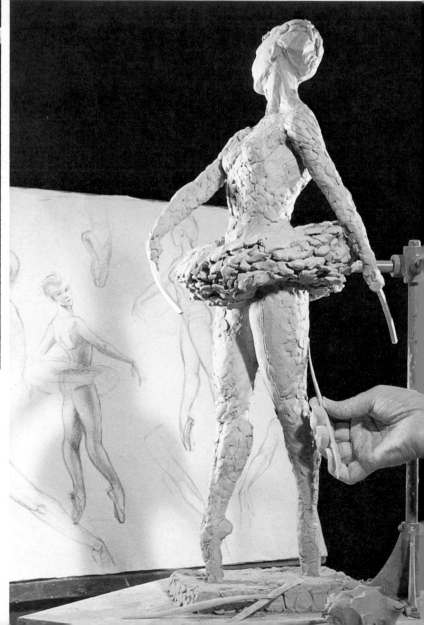

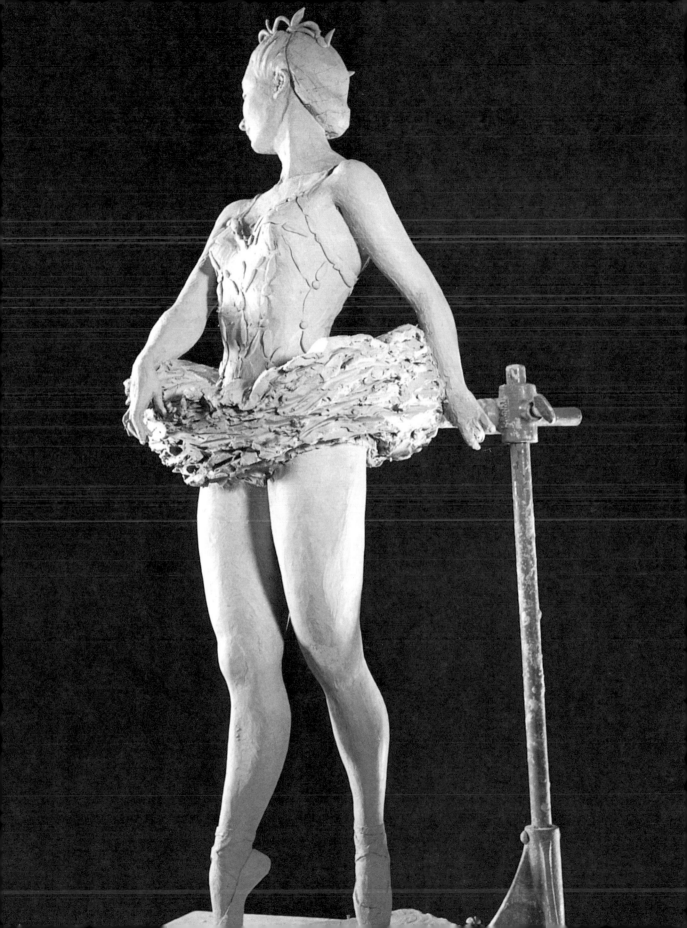

MOULDING AND CASTING

The process for moulding and casting the dancer is the same as that described for the head (pp. 26–32) and the torso (pp. 45–49). However, the pose of the dancer calls for careful consideration when selecting the position for the seams. Each sculptor will develop his own preference over separation positions; experience soon leads to confidence and speed in the selection. A good rule is to select the best main master mould, if possible, running down the length of the whole subject. Obviously, a separating seam will be needed where the supporting iron enters the clay (unless an unscrewable one is used).

For this figure, the brass shim method (see p. 26) was used. The clay band method (see p. 26) could also have been used.

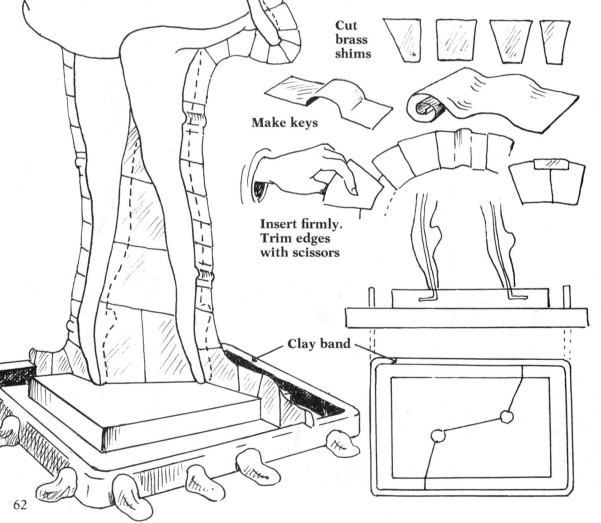

Cut brass shims

Make keys

Insert firmly. Trim edges with scissors

Clay band

62

First plaster coat

When the shims are in place, coat the baseboard with a clay slip, make a clay band around the base (see illustration) and put some extra clay around the supporting iron. Then mix the plaster as previously described (see p. 24). Flick the slightly coloured plaster onto the model, making sure the plaster gets into awkward crevices. If need be, blow the plaster into areas such as eyes, ears etc. Keep the first coat thin and even over the model though do build up the plaster on both sides of the seams. Be careful not to disturb the shims. When finished, leave the plaster to dry and wash hands and bowls.

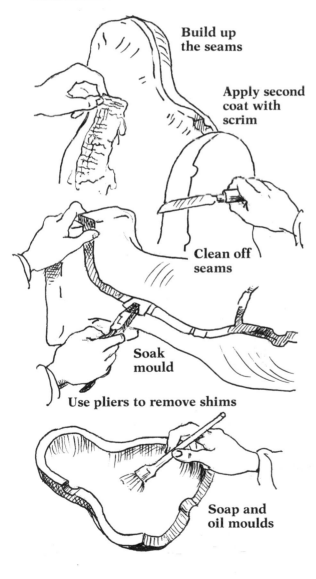

Build up the seams

Apply second coat with scrim

Clean off seams

Soak mould

Use pliers to remove shims

Soap and oil moulds

Second plaster coat

Brush a little clay slip here and there on the first coat of plaster. Do *not* completely cover the model with slip. Mix the second coat of plaster and apply it to the model. Dip pre-cut pieces of scrim which have been dampened into the plaster and place them on the model in weak areas such as the neck and base which might need strengthening. Do *not* cover the seams with the scrim. Build up the plaster coat as evenly over the modelling as possible and smooth it neatly. Clean off the seams until all the edges of the shims show. A knife is the best tool for this. Now leave the mould for a few hours to mature.

Soaking and separating the mould

It is now necessary to remove the mould from the board. Since the clay base under the feet is not fixed to the board, some water will help free the base.

Unscrew the armature support iron or, as the support used in the photograph, the back wing nut and slide the figure forward leaving the mould free but for the protruding bar at the back.

The whole mould can now be immersed in water. When the clay begins to swell, the mould will open a little. Carefully remove some of the shims with pliers and, as soon as possible, lift the mould pieces away from the clay one by one.

Clean the moulds with a soft brush and water until all traces of clay are removed.

Never leave pieces of mould for any length of time without fitting and tying them together or they will warp and this will distort the filling when casting.

Soft soap and oil the mould

The inside of the moulds must now be sealed. With a good quality soft brush work some soft soap into the moulds. Clean away the froth and repeat the soaping. Wipe clean the insides of the moulds and then give them a light coating of olive oil. Remember to treat the seams and edges also. (See p. 30 for further information.)

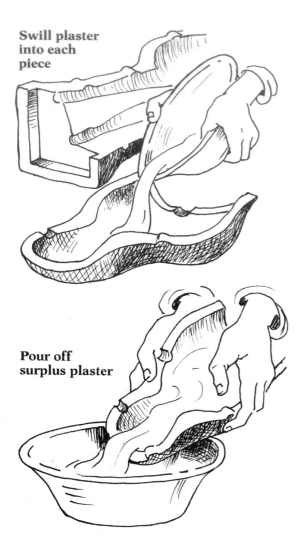

Swill plaster into each piece

Pour off surplus plaster

MAKING THE CAST

First plaster coat

Mix enough plaster to thinly coat one of the mould pieces. Do not attempt to fill all the pieces at once as each will need careful attention as to the thickness of the plaster and to the cleaning of the edges of the mould before the plaster gets hard. Make sure that the plaster is a good strong mix.

Swill the plaster into the moulds. This should help to give them an even coat all over and up the vertical sides. Pour off the excess plaster and clean the edges of each piece before the plaster sets. (Any plaster left on the edges would prevent a perfect fit when putting the moulds together later on.)

Strengthening

Bend some thin but hard metal into the same basic shape as the mould. (If you use iron, make sure that it is sealed so that it doesn't rust.) Make sure that the metal is long enough to go through the toes of each foot down into the base because the figure is very weak at these points. Tip the shaped metal into the mould using blobs of plaster to hold it in position. Make sure that the metal does not prevent a tight fit when the moulds are put together.

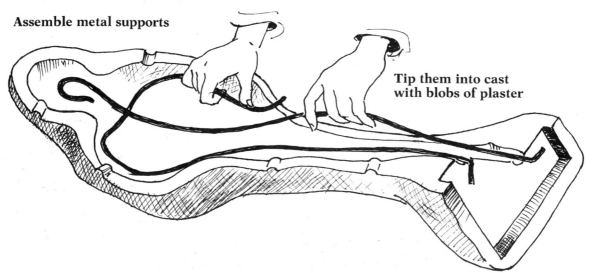

Assemble metal supports

Tip them into cast with blobs of plaster

ASSEMBLING AND CASTING

Give the moulds a second coat of plaster followed, while still wet, with a layer of scrim dipped into the plaster and laid flat. Small pieces lay in more easily. They can overlap. Build the scrim right up to the edges but be careful not to intrude on the seams.

When the plaster is dry enough, fit the head to the main mould and tie it firmly in place with twisted wire or cord. Put some scrim and plaster across the outside seams. This will also help hold the pieces in place.

Up end the mould and swill the plaster around to fill in the seams. Where possible, also put a little scrim along the inside seams to strengthen them. Clean the edges of the mould so that they are ready for the addition of the next piece of mould.

Final plaster in base

Fit the third mould and secure it, adding some scrim over the seams for strength.

Bend a piece of hard metal to fit around the inside of the base and then put it aside. Leave a hole in the middle of the base for screwing to the mount later on. Prop the mould upside down or, better yet, get someone to hold it for you. Mix a little strong plaster. This must be used quickly before it starts thickening. Gently swill the plaster around to fill the seams. Finally, fill the base and lay in the metal.

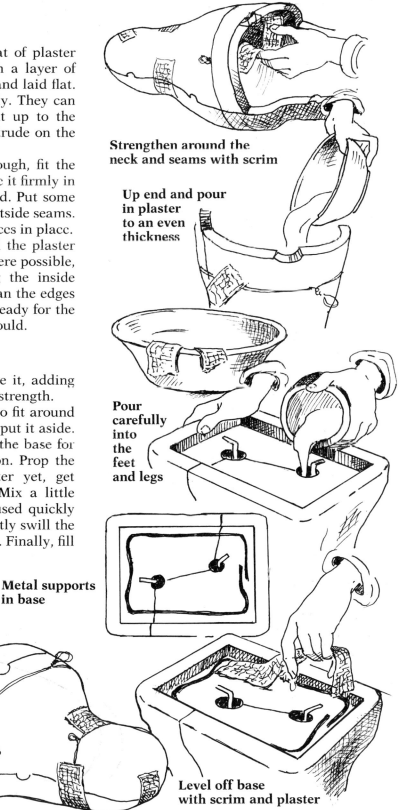

Strengthen around the neck and seams with scrim

Up end and pour in plaster to an even thickness

Pour carefully into the feet and legs

Metal supports in base

Level off base with scrim and plaster

Chipping out

When the mould and cast have dried out, support them on a piece of sacking or an old cushion. With a blunt chisel and a wooden mallet, carefully chip away the mould. The sight of the coloured layer of plaster is a warning sign to proceed carefully. Remove the coloured layer and then pick out any plaster that is left in the crevices. If there is any damage, wet the area well and apply some fairly weak plaster. (Use weak plaster as the cast will absorb moisture from the new filling.)

MOUNTING

The plaster base of the ballet dancer is both protected and enhanced in appearance when placed on a wooden base somewhat larger than the plaster base. Here, three nails were driven into the base and some plaster and scrim twisted around the nails and fixed into the base which had been left partially hollow for this purpose.

BRONZING

At this stage, the model should be bronzed because the white of the plaster casts reflections and details cannot be appreciated. See p. 34 for instructions on bronzing.

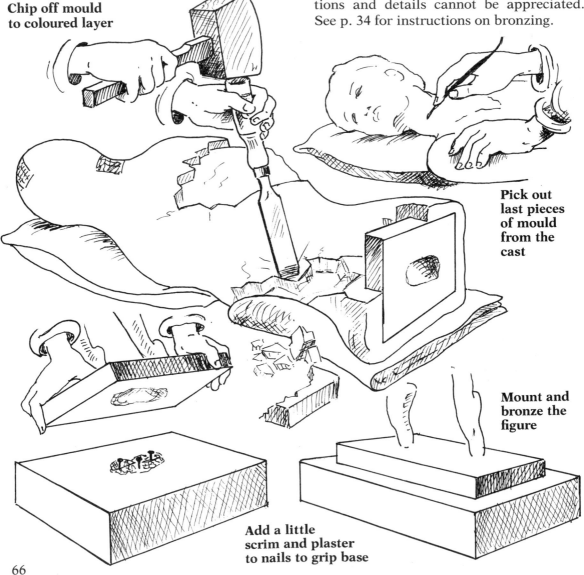

Chip off mould to coloured layer

Pick out last pieces of mould from the cast

Mount and bronze the figure

Add a little scrim and plaster to nails to grip base

Modelling in Terracotta

TERRACOTTA MODELLING

Terracotta modelling is extremely attractive to sculptors because the clay has a sympathetic, natural colour over which the sculptor has some control of tone in both the mixing of the clay and in the firing. The small risk of damage in firing is offset by the advantage of keeping the original modelling without the necessity of moulding and casting.

Terracotta clay is a clay that has some iron oxide mixed into it. It is the iron oxide that gives it its reddish colour. Terracotta clay can be purchased from sculptors suppliers (see list on p. 127), some art shops, or from most local potteries who will also usually do the firing for you if you wish. The sculptor who is willing to mix his own clay can obtain just the stronger or softer shades that are needed for different subjects. Terracotta recipes are given on p. 69.

MATERIALS AND EQUIPMENT

The equipment needed for terracotta modelling is the same as that for clay modelling (see list on p. 8) with the addition of the following:

1 cwt or less of terracotta clay
Some iron or wooden pegs with angle brackets
Some hollowing tools
Brick earth, sand and fireclay

Some clay terms

Terracotta	clay with iron oxide in it
Grogged clay	clay with ground, fired clay added to it
Leatherhard	clay partly dried out and firm
Green clay	unfired clay
Slip	clay watered down to a creamy consistency
Drying out	clay allowed to dry out slowly and finally put near a kiln to dry out completely before being put into a kiln for firing
Biscuit	already fired clay. The higher the temperature, the darker the colour

Mixing your own terracotta

(See the recipes given on the next page.)
Mix (powder) ball clay with 10% to 15% red iron oxide; sieve them to obtain an even colour. Then soften down with water. Experiment by mixing these clays with brick earth, keeping a record of the proportions used.

Always add fireclay, by kneading a small quantity into the clay either before or during modelling. This is to safeguard against the splintering of finely ground clays when they are not modelled to an even thickness throughout. It also has a pleasant, neutralising effect on the colour. Sand can be added gradually to fine clays to obtain a similar effect if there is no brick earth available.

Store clay in a bin (not made of tin) or in extra thick polythene bags. Store dry clay away from damp or dust. Clay that has become completely dried out can be re-used if it is pulverised with a mallet and then watered down again.

TERRACOTTA RECIPES

Red terracotta Cone 06

Buff clay	20
Red clay	35
40s mesh grog	30
Flint	15

Red terracotta talc body Cone 06

Buff clay	20
Red clay	20
Talc	30
40s mesh grog	30

Grey terracotta body Cone 06

Buff clay	34
Talc	30
40s mesh grog	30
Iron chromate	6

Yellow orange terracotta body Cone 04

Kaolin (EPK)	25
Talc	25
Nepheline syenite	12
Ball clay	10
Jordan clay	15
Plastic fireclay	13
40s mesh grog	10

Brick red terracotta body Cone 04

Redart clay	60
Plastic fireclay	10
Jordan clay	10
Silica	5
Talc	5
Kentucky ball clay	10
40s mesh grog	10

Brick red terracotta body Cone 04

Ball clay	20
Red clay	25
40s mesh grog	30
Silica	15
Jordan clay	10

KILNS

There is a wide range of kilns available for the sculptor who wishes to do his own firing. These range from simple electric kilns to gas and oil-fired kilns and even wood-fired kilns. They can be top loading or front loading. They can range in size from the quite small (17" x 18") to the very large. Prices also vary according to size and fuel.

When selecting a kiln, considerations of cost, space available for housing the kiln (and fuel), type of fuel, and capacity needed must all be taken into account. Electric and gas-fired kilns are probably the simplest and cleanest to use but each individual will have to decide which kiln would suit his situation best. Pottery suppliers (see list on p. 127) carry a wide range of kilns and they are very knowledgeable about them. It is a good idea to talk your requirements through with your supplier to see which kiln and fuel would be best suited to you.

It is possible to build your own simple kiln. A helpful book is Andrew Holden's *Self-Reliant Potter*, published by A & C Black.

Note

When having modelling fired by a local pottery, they usually wish you to use clay purchased from them as this would have been tested and found best in their kilns.

Remember

When modelling for firing, do not use a wire or armature which would need to be left in the clay as this would result in damaging the fired clay. When an armature must be used for a large piece of sculpture, the sculpture must be cut, hollowed out and every piece of wire or support removed.

Modelling a Terracotta Child's Head

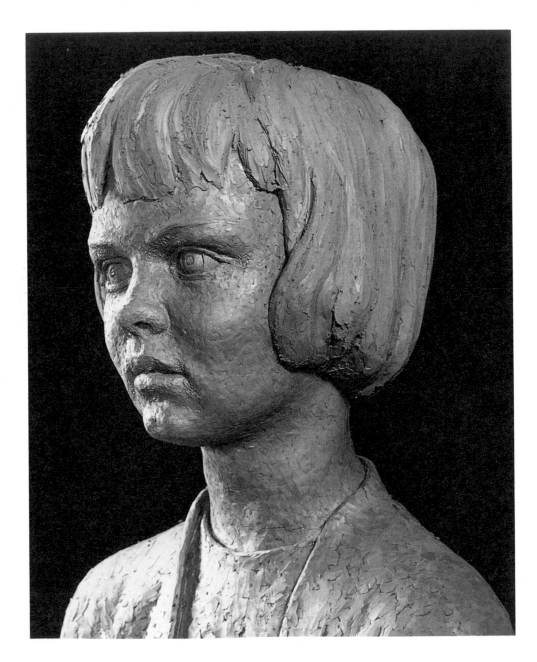

As with the clay portrait described on pp. 14–21, the sculptor will first need to put his subject at ease. During this time, make sketches of your subject. These will give you an idea of the most characteristic attitudes of your sitter. If you can take visual note of the 'set' of the head – most of us carry the head either a little to the left or right, some with the chin raised or pulled back, then the portrait will come much more easily later on. Note all the measurements you have taken on your diagrams. (See p. 15.)

STARTING THE CORE

The charm of this little girl's head is so much in the balance of her slim neck and shoulders that it was decided to include the shoulders in the portrait. When the subject is suitable, this is a particularly good way of using terracotta.

Select a board large enough to take the shoulders of the model. Put two lifting strips on the bottom of the board and fix a peg of wood to the board with four firmly screwed angle brackets (see illustration). (Boards with pegs which have bolts right through them can be purchased from sculptors suppliers.)

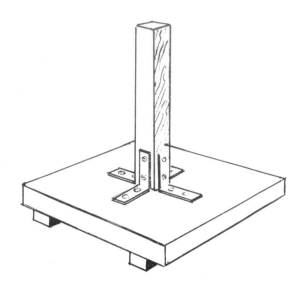

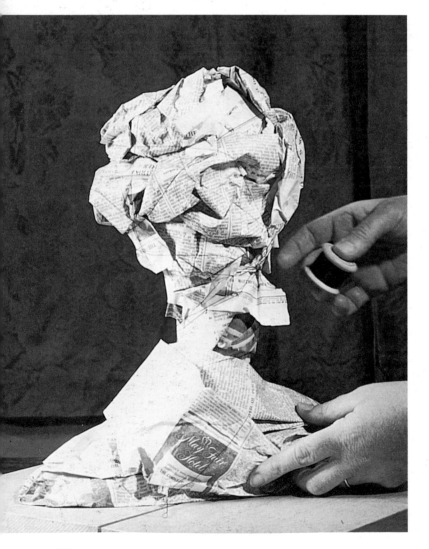

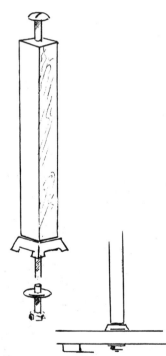

Wrapping with paper

Wrap paper around the peg and tie the rough shape in place with cotton thread. Keep the neck area as thin as possible.

STAGE ONE – CLAY

With clay that is in good condition, build the head up from the base. Pack the clay in well with the ball of the thumb. All the clay should be of the same consistency.

Pack core clay

Pack the clay in as evenly as possible with wooden tools.

Wooden tools

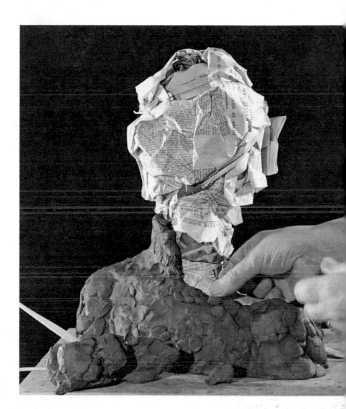

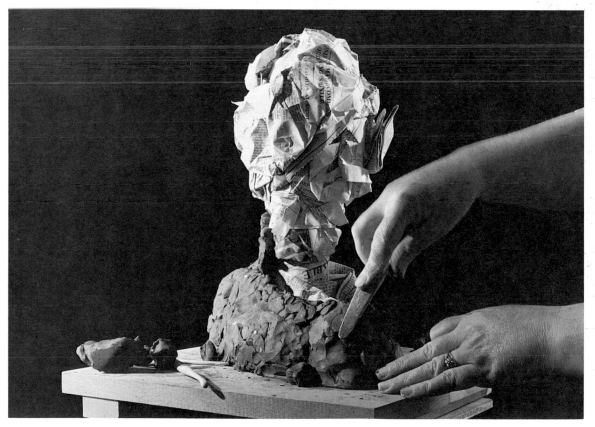

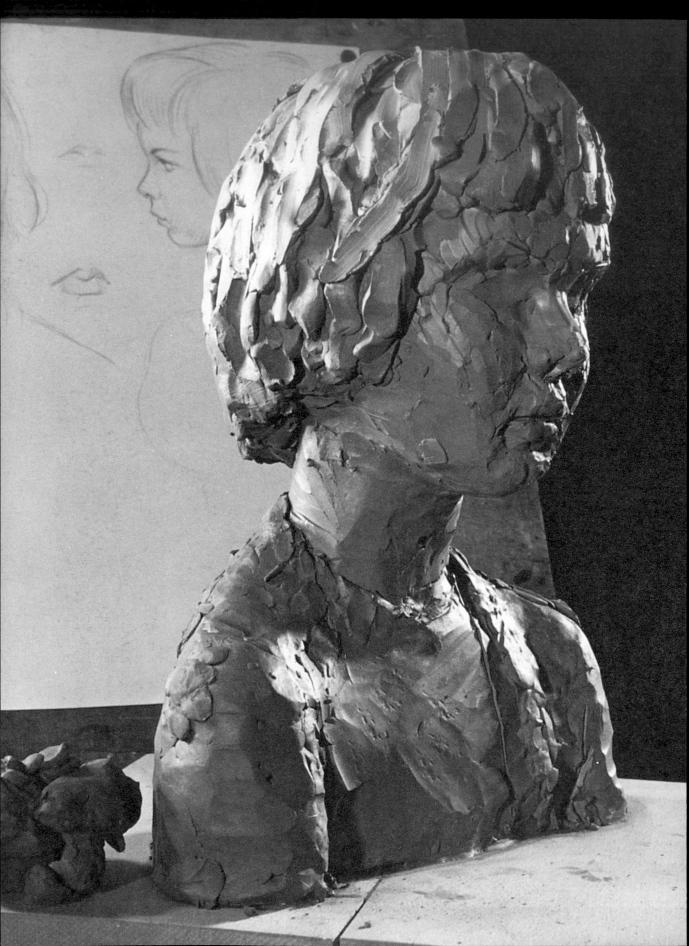

STAGE TWO

Making full use of the sketches and your model, block in the whole head, paying particular attention to the main constructional measurements that you took previously with the calipers. Fix the position of the bridge of the nose and work all the measurements from this point. Inserting matchsticks into the clay as an indication of exact points can be a great help.

Bring the head and shoulders to the same standard all around. Refrain from detail work at this stage; as so often happens, when the richer forms are developed, any detail work done too soon can be found to be smaller or meaner than it should be.

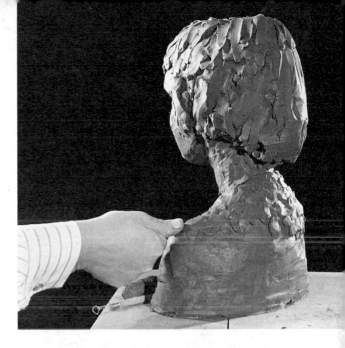

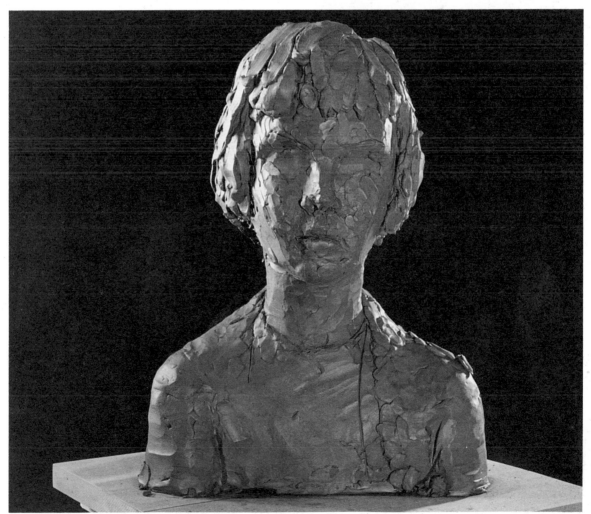

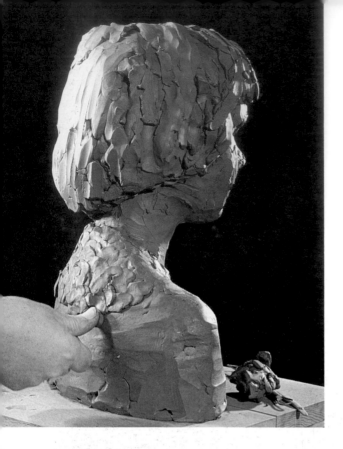

Modelling in controlled stages

When the head is satisfactorily constructed to this stage, the measurements and bulk checked and re-checked and the masses are in the correct relationship to each other, then the building of the broader forms can begin. Roll the clay between your fingers and thumb and apply it in uniform sized pieces for each stage. This will help, with continual turning, to bring the portrait up to completion in controlled stages.

Clay condition

It is most important to keep the clay model in good condition between sittings. Do this by using a fine spray of water, but be careful not to soften the clay too much. Insert a piece of wire to protect the face and then cover the whole work with a polythene bag. If this is tightly sealed at the bottom, the work will remain in excellent condition for a week or more.

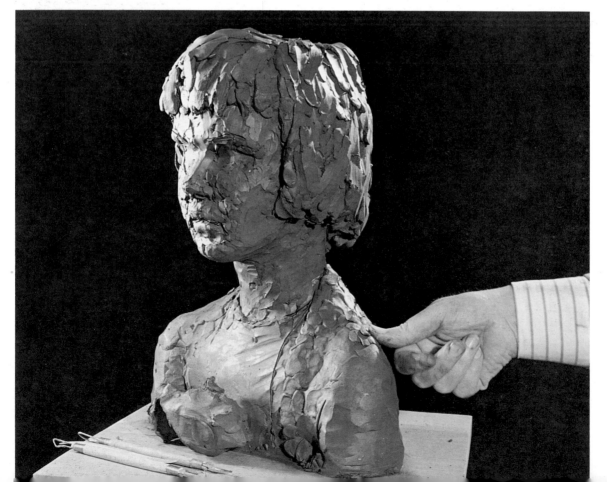

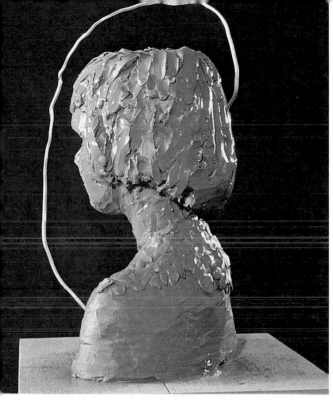
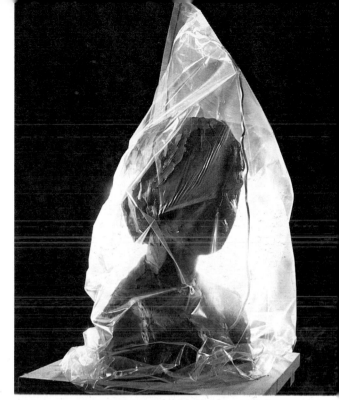
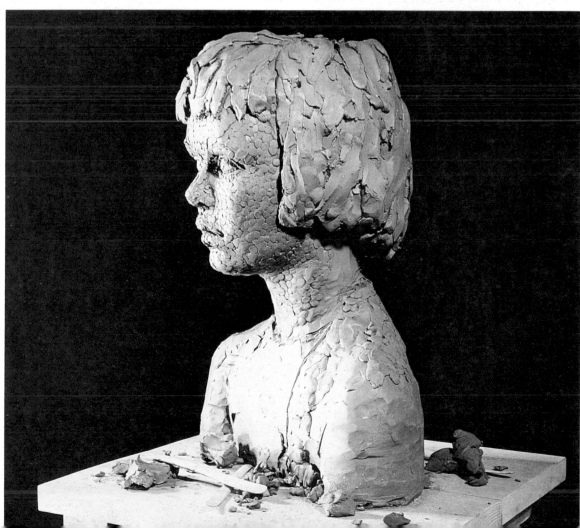

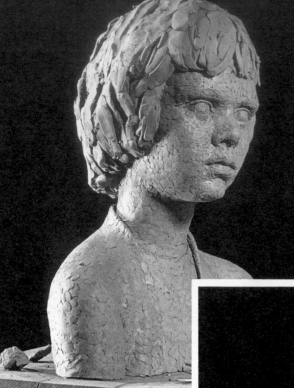

LAST STAGES

Here are shown left and righthand views at two distinct stages of the portrait. In the second stage it can clearly be seen how the broader forms are linked together. The likeness now begins to be more obvious. Care should be taken between these stages not to hurry on to the final finishing until the basic, broader forms have been satisfactorily achieved.

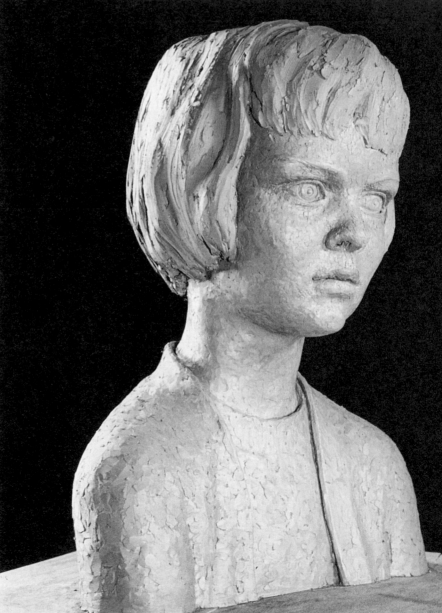

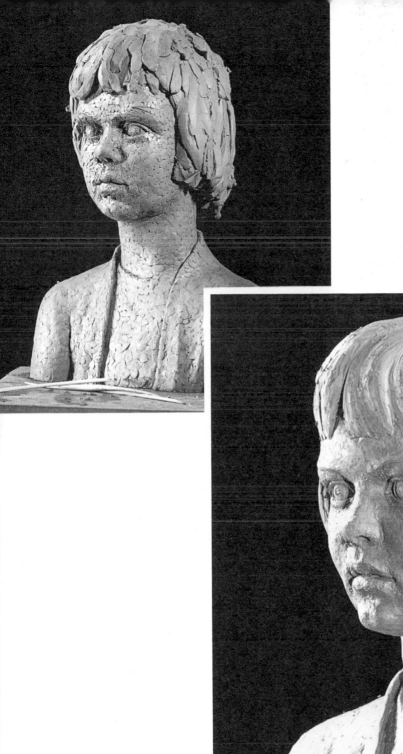
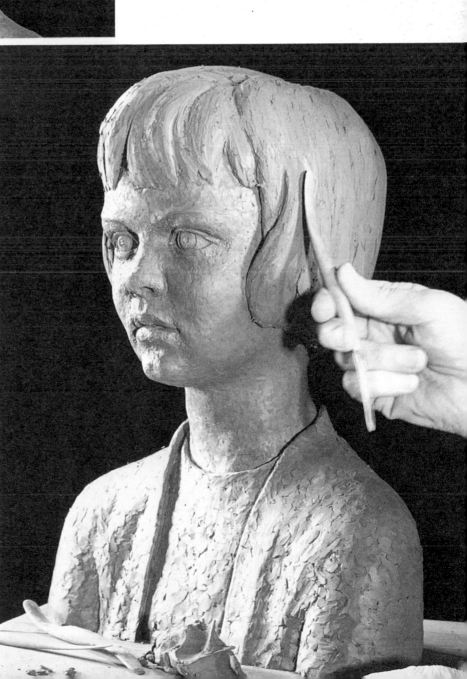

Details

Details of this finished head help to show how the form has been sought after and gradually found. The rich, full and lively eyes bring the portrait to life and are in keeping with the taut nostrils. The sensitive and complex forms of the relaxed mouth are particularly charming. The whole portrait has captured the mental alertness, charm and absolute ease of the young sitter.

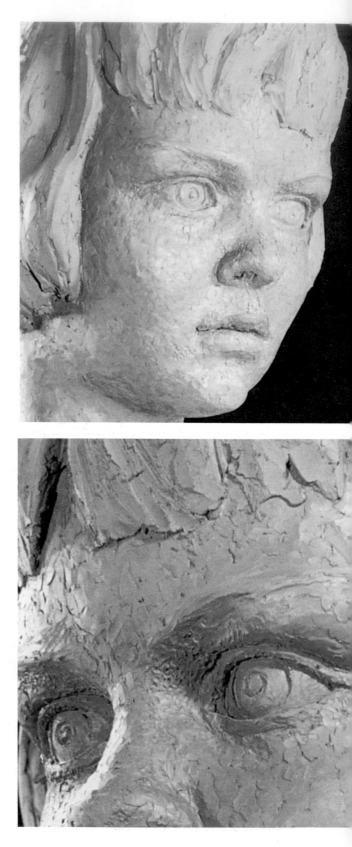

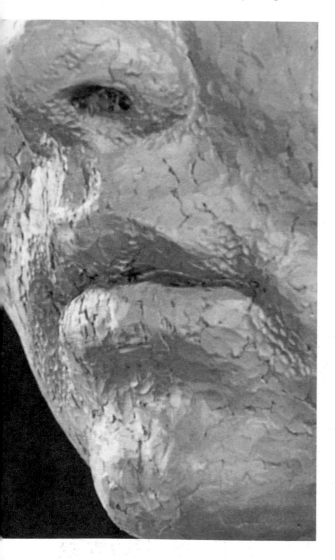

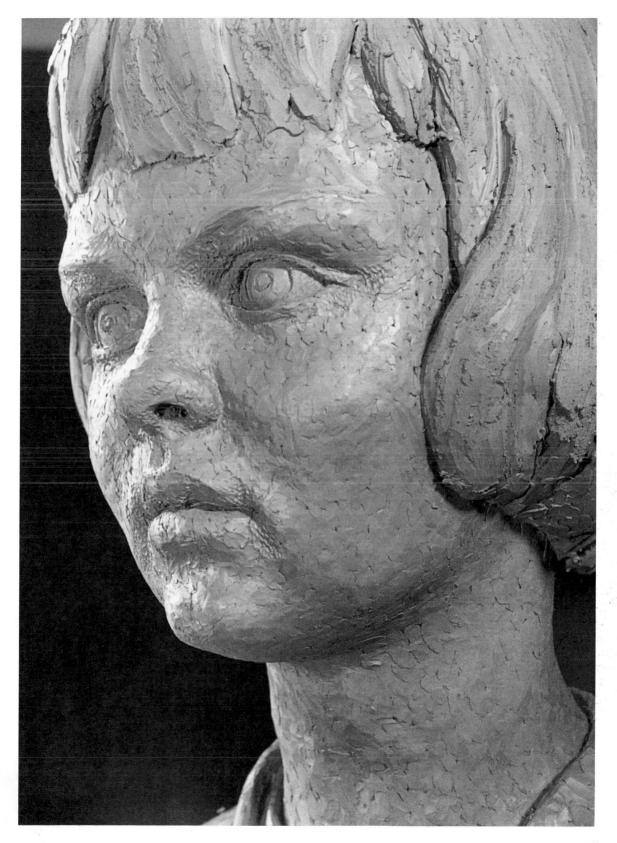

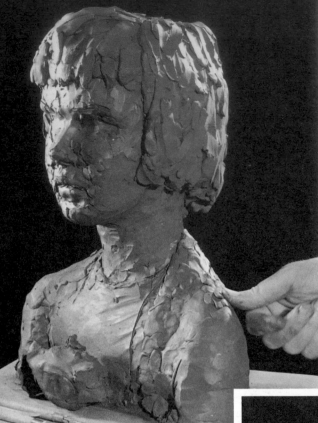

A look back

These three photographs enable us to look back at the various stages of the portrait. Note how, after the core, the modelling was done almost entirely with the fingers. Then, in the middle stage, pellets of clay were pressed home with the thumb or a boxwood tool (not too small a tool but well curved). As the sittings continued, the broader forms became more detailed as smaller pieces of clay, put on with smaller tools, were necessary.

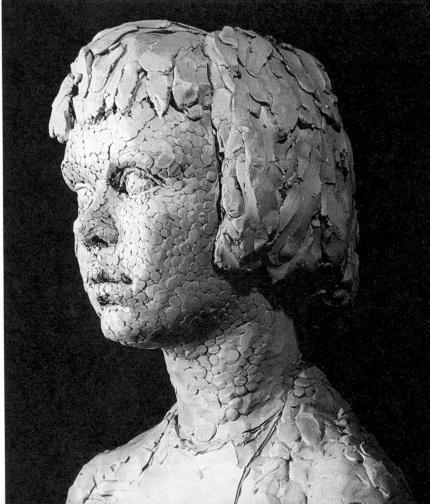

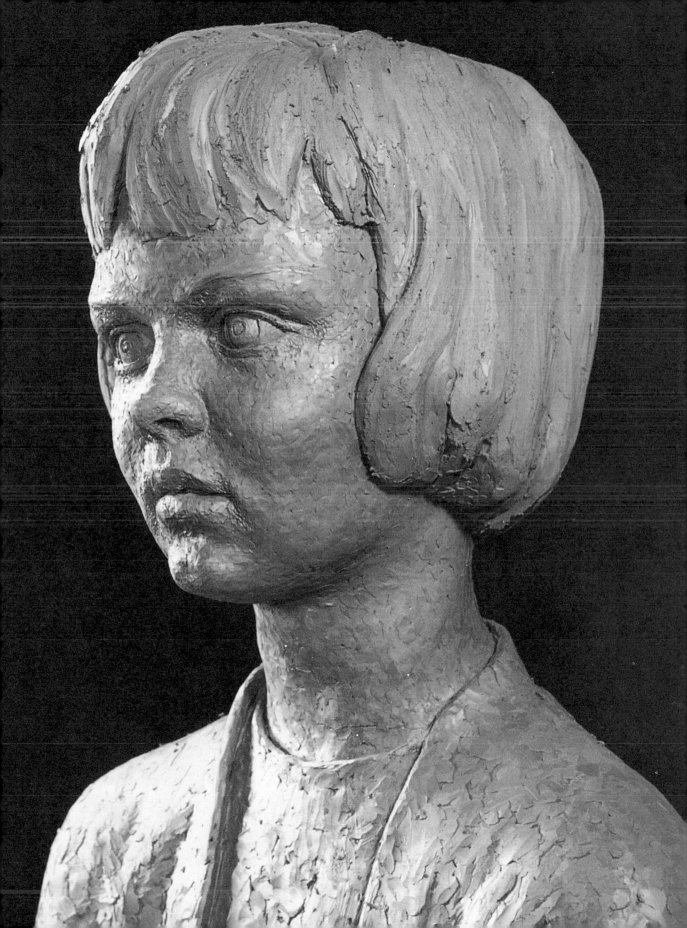

PREPARATION FOR FIRING

Allow the finished portrait to become leatherhard, making sure that the process is slow and gentle so that the shrinkage is even. Then, when the clay is leatherhard, lift the head gently from the board and peg.

In this portrait, the head is already hollowed out by the paper to a thickness suitable for firing, and could be put straight into a kiln after it had completely dried out. However, if the head is made of solid clay or if you are not sure that the head is not too thick at any point for safe firing, it will be necessary to cut a 'cap' and hollow out the head.

Cutting a cap

Take a length of fine gauge wire and wrap the ends around pieces of dowel to form handles. Then wrap the wire around the cap of the head (see illustration), cross the wire ends and pull the hands apart. This will make a clean cut.

Lifting the cap

Lift the cut cap from the base of the head, snipping away paper and cotton thread as necessary. Place the cap hollow side up onto a soft cloth or cushion that has been covered with polythene. With the aid of a griffon and a wire-ended tool, even out the clay to a thickness of between $\frac{1}{2}''$ and $\frac{3}{4}''$. Be careful not to distort the shape of the cap. Cover the cap with polythene to keep it from drying out while you are dealing with the larger piece of the head.

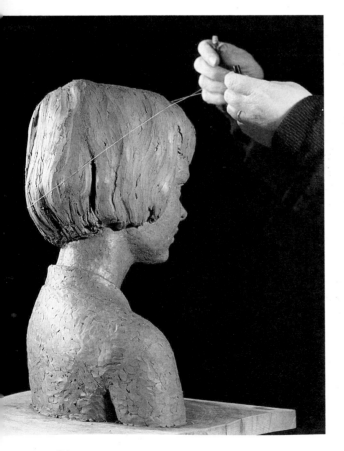

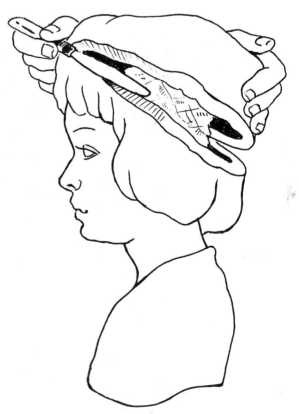

Hollowing to an even thickness
Removing from board and hollowing out

Cut away the paper and cotton thread close to the peg in the main part of the head. Cut down to the neck area. Hollow out this part of the head as far down as you can.

At this point, the leatherhard clay may have shrunk away from the board enabling it to be lifted from the peg. If necessary, wet the board at the base a little and slide a knife around the clay until it is free.

Holding it by the shoulders, lift the head from the peg and board. Lay it carefully down on a polythene covered cushion. Make sure to support the slender neck. Then carefully, using a griffon and a wire-ended tool, even the clay to a thickness of $1/2''$ to $3/4''$. If any points seem too thin, build them up from the inside by coating the inside with a bit of slip and then gently pressing some clay into the weak position.

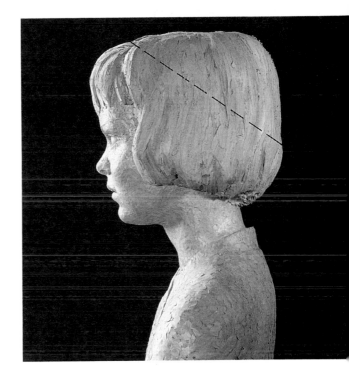

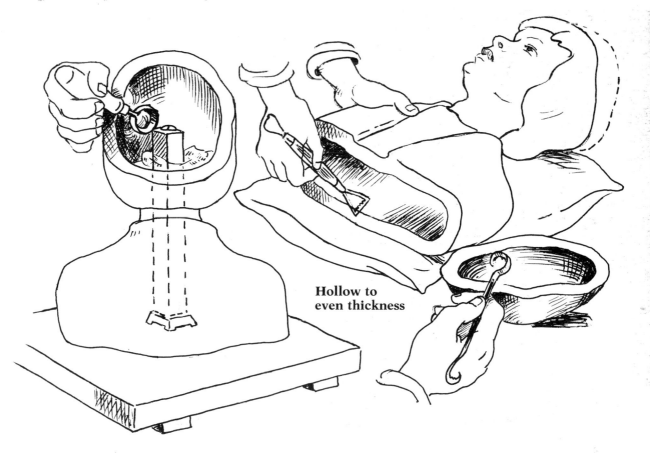

Hollow to even thickness

85

Replacing the cap

Before replacing the cap, score the edges on both pieces. Then brush some clay slip on both seam edges. Replace the cap carefully and squeeze the two pieces together by pressing gently but firmly. Tool down the seam and make good the modelling until the seam can no longer be seen.

If care has been taken while modelling to press the clay firmly together to exclude air pockets, and the clay is of a reasonably even thickness, then there should be no fear of damage during firing. An extra precaution can be taken by piercing the clay right through with a needle-like tool in such places as the ears, the collar and the crevices around the hair, nostrils and corners of the mouth. This will allow air circulation when firing.

Allow the portrait to dry out completely and then it will be ready for firing.

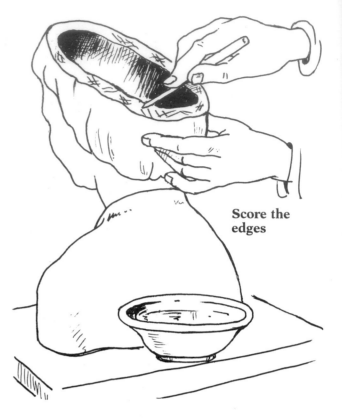

Score the edges

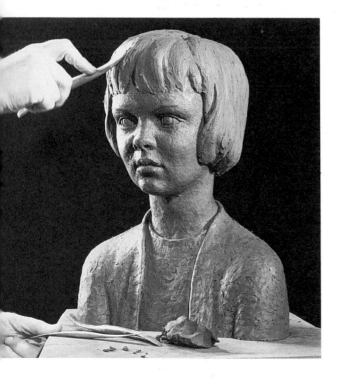

FIRING

See comments on firing on p. 98.

MOUNTING THE SCULPTURE

The head illustrated stands on its shoulders, but it will be greatly enhanced if it is placed on a wooden base. The base should always be of a generous thickness. Sand the wood and varnish it as necessary. This head could have been just placed on the mount but, to prevent it moving about, three short pegs were fixed with glue into the holes that had been drilled in the wood base. (A portrait head which finishes at the neck needs a wooden dowel or perhaps a copper rod fixed inside of the head and in the mount. See p. 32.)

Modelling a
Terracotta Torso

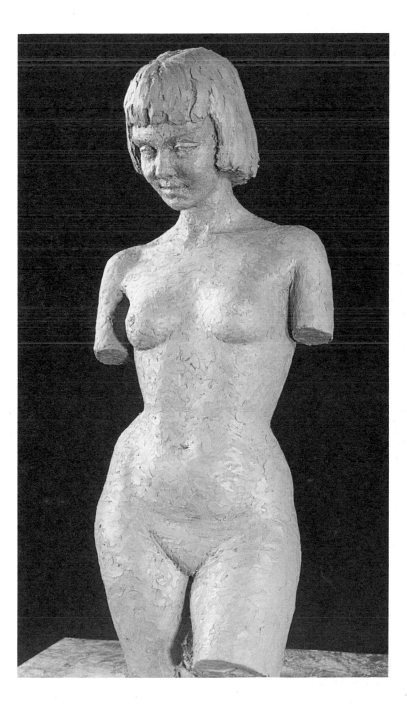

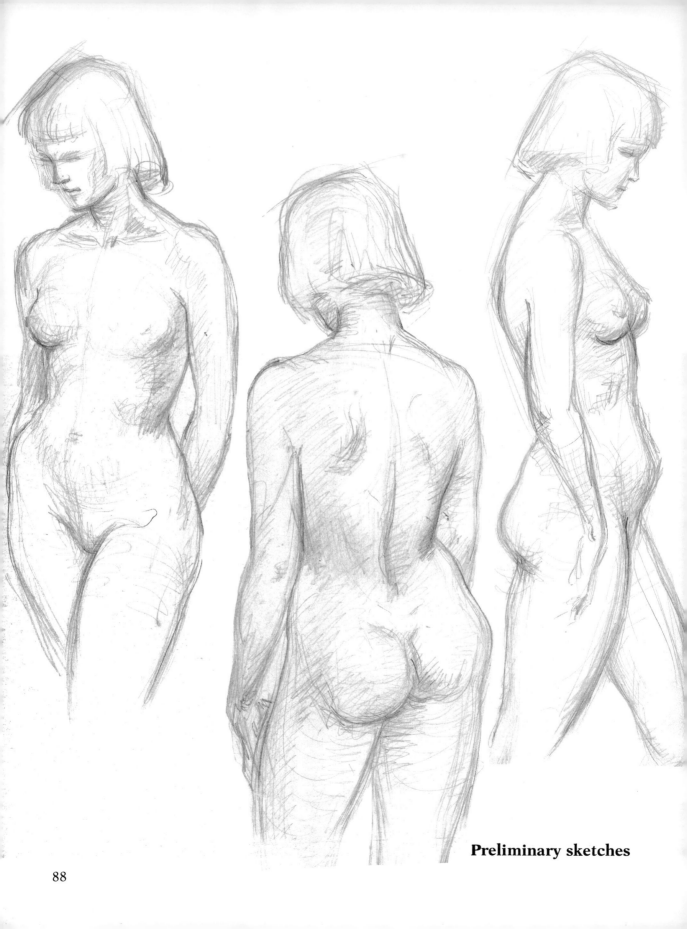

Preliminary sketches

The torso is a good choice of a subject. Although by no means easy in form, it is comparatively solid and straightforward and yet it allows the student to show his individual skill. A torso of any size makes a beautiful and satisfying piece of sculpture.

BEGINNING

Make sketches of the subject so that you have a clear understanding of its form. This will help you to keep in mind the axis as well as the simple planes and angles of the figure. This will, in turn, help you later to portray the pose, balance and particular character of the subject.

The peg

Take a board and firmly fix to it a peg of iron or wood (see illustration). Then wrap some tissue paper around the peg and tie the paper on with cotton thread. Keep in mind that when the torso is complete, the paper should be just loose enough to be slipped from the peg. It is a good idea to have lifting bars under the board (see p. 10) and to give the board a coat of shellac before starting. This will preserve the wood from the damp clay and extend its life for many years.

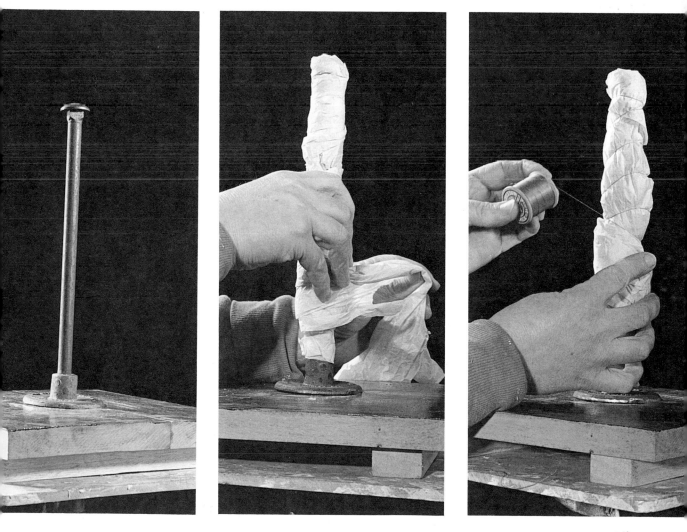

STAGE ONE – BLOCKING IN

First of all, make sure that the clay is in good working condition, that is moist enough to be easily worked and yet dry enough for the fingers to remain clean. Then block in the torso, paying particular attention to the centre line of the figure; the full weight should be upon the right leg. Note that the angle of the pelvis slopes down acutely from right to left, balanced by the shoulders sloping from left to right. The head, leaning forward, has an axis of its own.

Remember to spray the clay and cover the modelling with a plastic bag between working sessions.

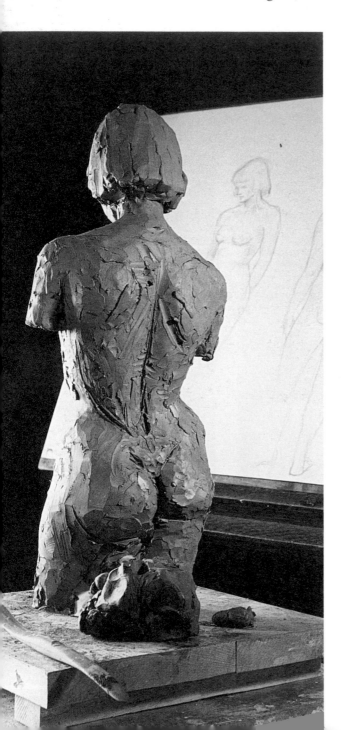
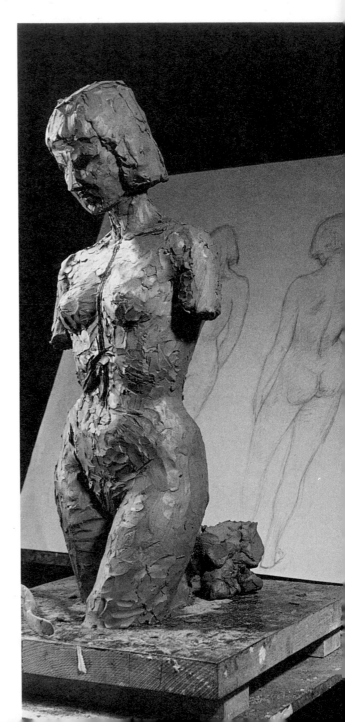

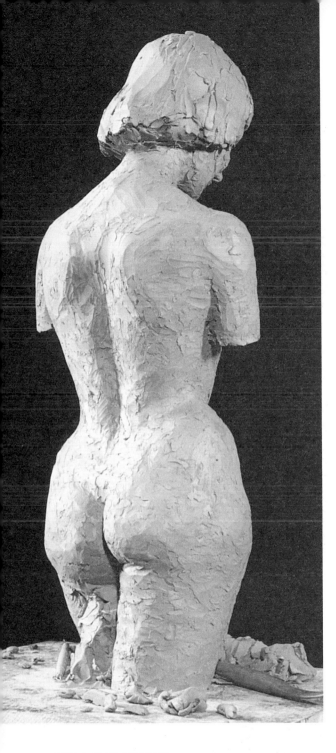
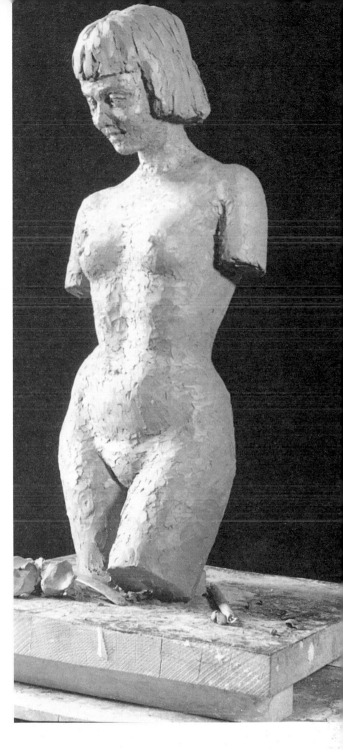

STAGE TWO

Having satisfactorily fixed the pose and proportions of the figure, start to build up the rich forms of the body. At this stage, avoid all temptation to carve the clay. Instead concentrate solely on building up the form using progressively smaller pellets of clay. Continually turn the model so that it develops to the same standard all the way around. This helps keep the three-dimensional forms in their correct relationship to one another.

91

STAGE THREE

In the finishing stages, the sculptor should discard his larger tools for smaller ones. Do not attempt to smooth out the modelling in any way. Leaving the tool marks will enhance the form and reveal where the artist has explored for detail.

The figure will now have a firm, live appearance; each view with its own particular charm, yet portraying the same feeling and character from all angles. The point at which the legs are cut is important – it gives the figure stability. Cutting a vertical section through the forward leg conveys lightness and movement to the torso.

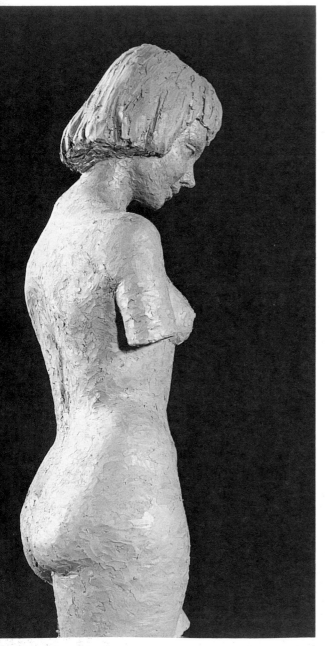

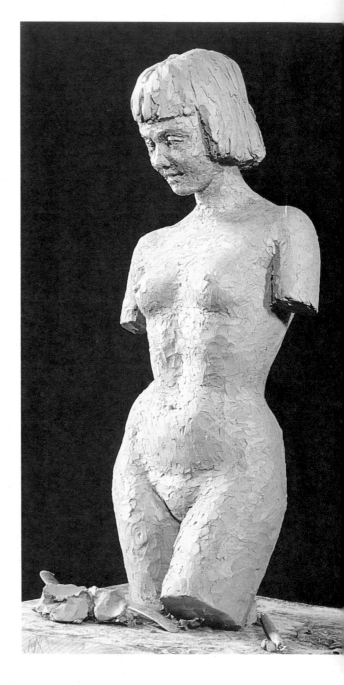

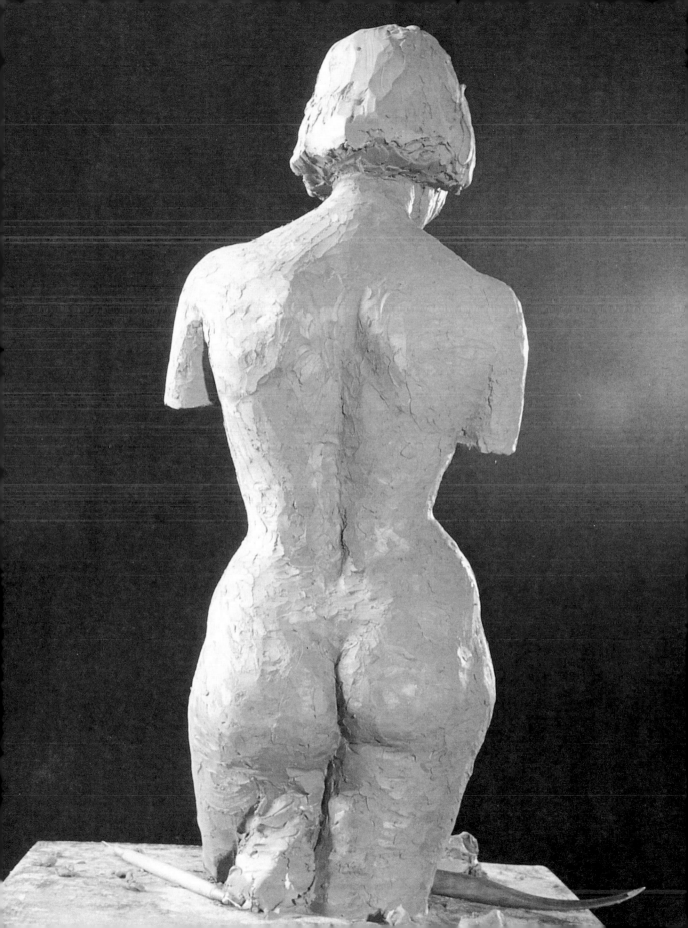

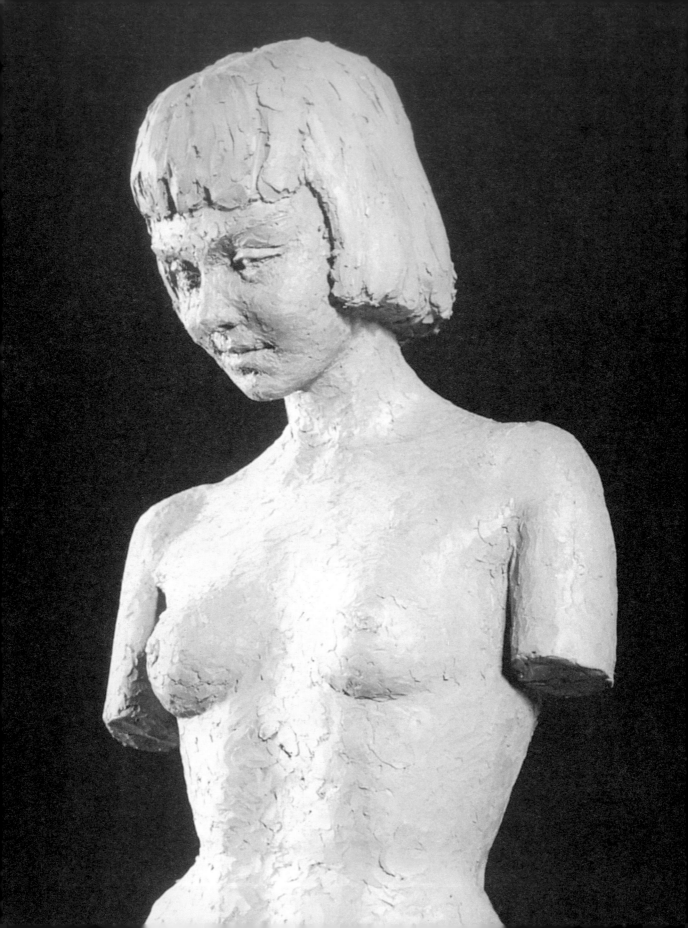

Details

The interesting texture of the modelling is clearly shown in these close-ups. This is an individual characteristic by which every sculptor's work can be recognised.

A satisfying finish

These photographs demonstrate how well the modelling has become tighter by the controlled building up of the many forms as they relate to each other.

Note how the angle of the supporting hip dives into the waist, making a rich deep arch into the abdomen. This is in contrast to the other, relaxed side of the figure. It can also be seen that it is not a 'smoothed' finish which has brought the modelling to a satisfying, finished stage but the well sought forms achieved at this stage of working with the clay.

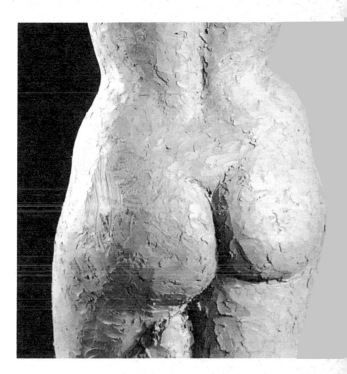

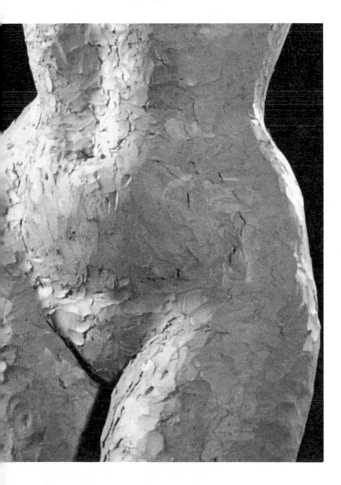

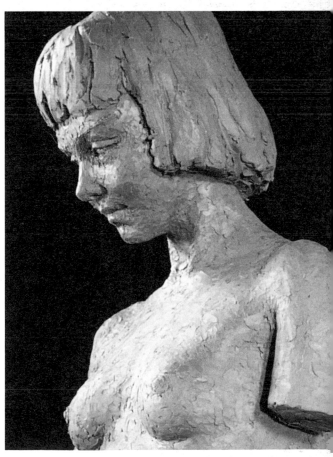

PREPARATION FOR FIRING

When you are satisfied with the modelling of the torso and that the standard of detail is consistent all the way around, leave the clay to slowly dry out well away from any heat. To do this, first leave the plastic covering open so that the air will circulate around the figure. Then remove the cover and leave the figure until it has become leatherhard – not completely dry but possible to handle gently without it being damaged.

Cutting the torso

Before the figure can be fired, it needs to be cut into two pieces so that the thickness of the clay can be checked. Ideally, the thickness of the clay should be as evenly consistent as possible. To cut the leatherhard torso in two, wrap a wire cutter around the waist of the figure, cross the wire and, with the two handles pulled apart, make a clean cut.

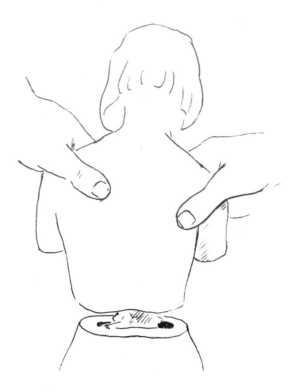

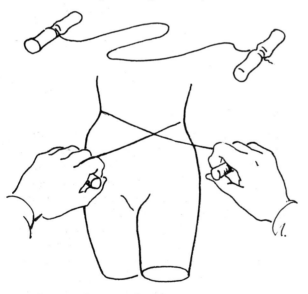

Lifting the top half

The top of the torso can now be lifted gently up from the peg. Cut away the paper and cotton thread so that the paper is not dragged through the figure, perhaps causing damage. Place the top half on a soft surface.

Lifting the base

Now, with the aid of a knife and some water on the base of the board, free the base of the legs and lift the bottom half of the torso up off the peg.

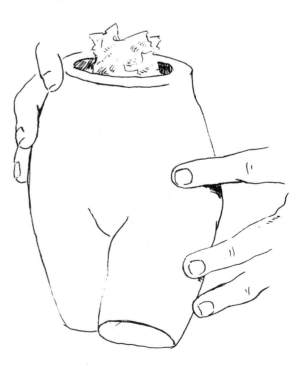

Hollowing out

Both pieces of the torso can now be easily cleared of paper, though any paper left in the figure will burn away during firing. With the aid of wire-ended tools, the pieces can be checked for the thickness of the clay and hollowed where considered too thick. In this figure, a little clay was carefully added to the inside of the neck by brushing on a little slip and then gently pressing a little clay into position. Great care was taken not to push the modelling out of shape.

Note: No wire, metal or armature should be left in the clay when firing because it would break the figure.

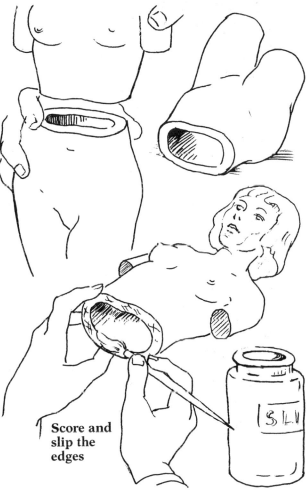

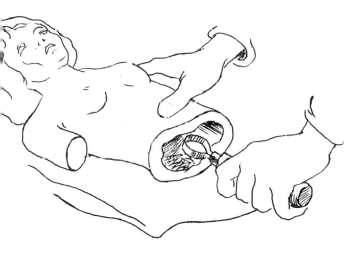

Score and
slip the
edges

Reassembling the torso

To reassemble the torso, the two pieces first need to be scored on the cut edges. The scored edges should then be coated with evenly applied slip. Next, the two slipped edges should be pressed gently but firmly together. Take care not to press the figure out of shape. When sufficiently dry, the seam can be worked over with a modelling tool until it can no longer be seen. Check that the torso stands at the correct angle on the supporting leg. Then allow the leather-hard clay to dry out slowly until it is completely dry and ready for firing.

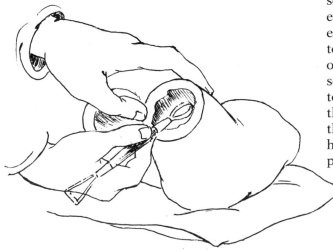

97

FIRING THE CLAY

Most local potteries are very willing to fire pieces of pottery or sculpture for a small fee. However, should you eventually wish to do your own firing, there is a wide variety of kilns to choose from, the electric type perhaps the simplest to operate. For more information on kilns, see p. 69.

If care is taken when modelling to press the clay firmly together so that air pockets are excluded and to make sure that the clay is of an even thickness, then there should be no fear of damage during firing.

Always make sure that the sculpture has been allowed to dry out slowly and that the clay is absolutely dry before it is fired.

The temperature of the kiln should be slowly brought up to 200°C. This allows any remaining moisture to be driven off. When the kiln reaches 500°C, the clay will undergo a chemical reaction after which it will no longer have the same physical properties of clay. Finally, the kiln temperature should be brought up to 1000°C. If the temperature is taken higher, the colour of the terracotta will deepen. Then switch off the kiln and allow it to cool.

MOUNTING THE TORSO

When the torso has been successfully fired, it will not be shown at its best unless it is mounted on a base of complementary dimensions. A squarish block was selected for this little figure which has a very stable, almost chunky appearance. The wooden block was sanded and polished and the position for the torso carefully marked round the standing leg.

Fixing the mounting bar

A thin ¼" copper pipe was cut long enough to go up the standing leg to the top of the inside of the figure with sufficient pipe left protruding from the bottom to fix into the block. Some glue and a little open weave bandage which was wrapped around the top of the pipe was then thrust in up to the top of the figure. This was held in place until it had set by wedging a piece of clay at the base of the leg. Then the pipe at the bottom of the leg was packed into position with bandage and glued in place.

Drilling the block

The protruding copper pipe may not be at the correct angle for mounting. However, this can be rectified by drilling the hole in the block to the correct angle. Ascertain the angle by holding the torso against the side of the block and then chalk down the side of the block as a guide for drilling. Glue the pipe well into the block and allow to set. Glue a piece of felt or baize under the block and the figure will be ready for presentation.

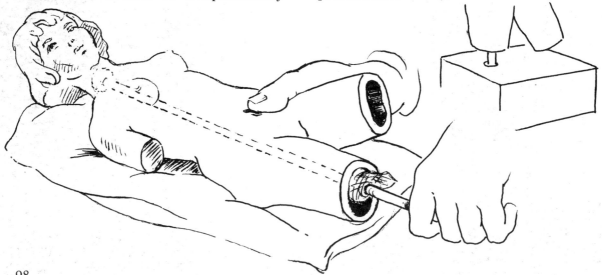

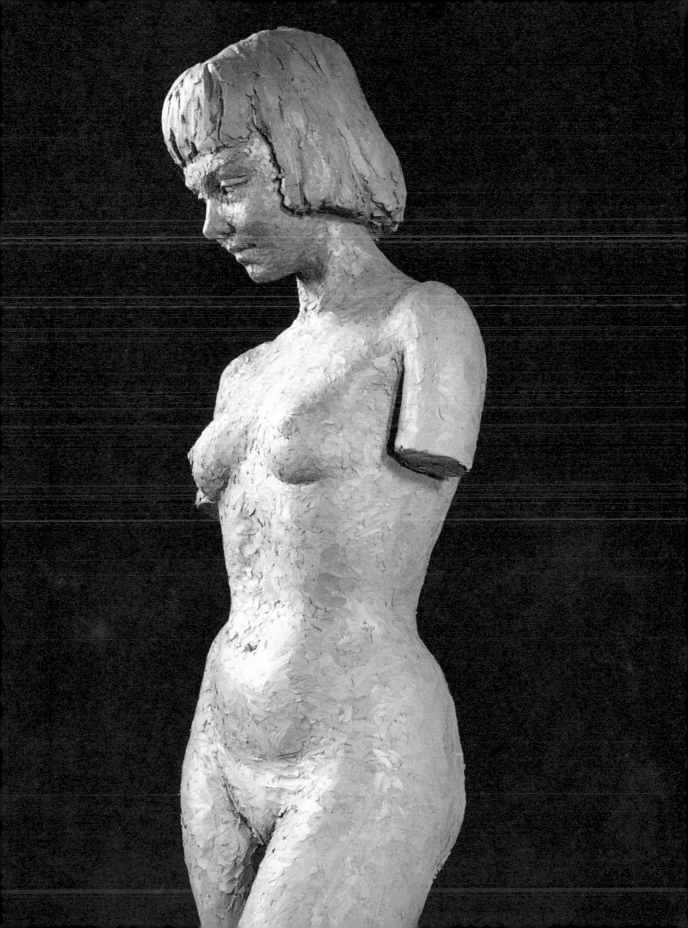

Modelling a Mother and Child Group

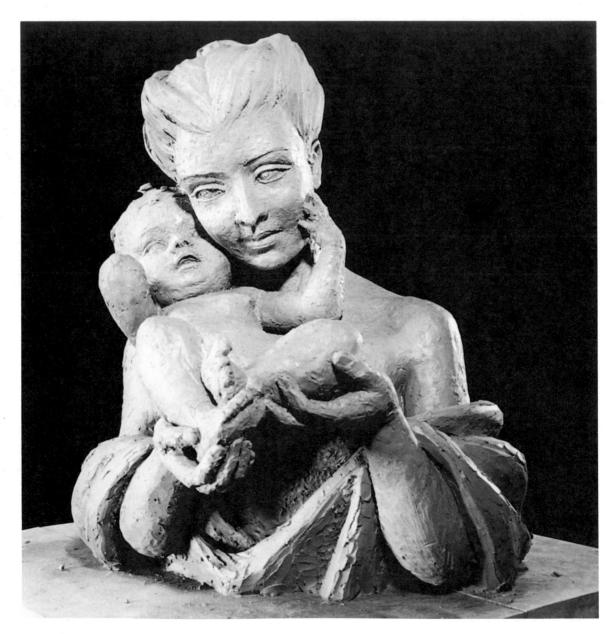

MOTHER AND CHILD

The inexhaustible variations on the subject Mother and Child, both in painting and sculpture, are proof enough of the unfailing fascination this subject holds for artists. The representation of the human relationship as well as the charming contrast of the large and smaller form, prove an irresistible challenge to the artist's skill and ability. For this example, which was done entirely from imagination, sketches and a tiny maquette (fired in solid clay) were made. With a group of this kind, it is advisable to settle the main problems of the subject this way before embarking on a larger, finished piece.

A clay maquette

It is not essential to make a maquette of the subject to be modelled. However, when you are tackling a group and want to be sure that the composition you have in mind is pleasing, making one or two rough maquettes would obviously be a useful exercise. The maquettes can be made of solid clay and either be fired or just allowed to dry out.

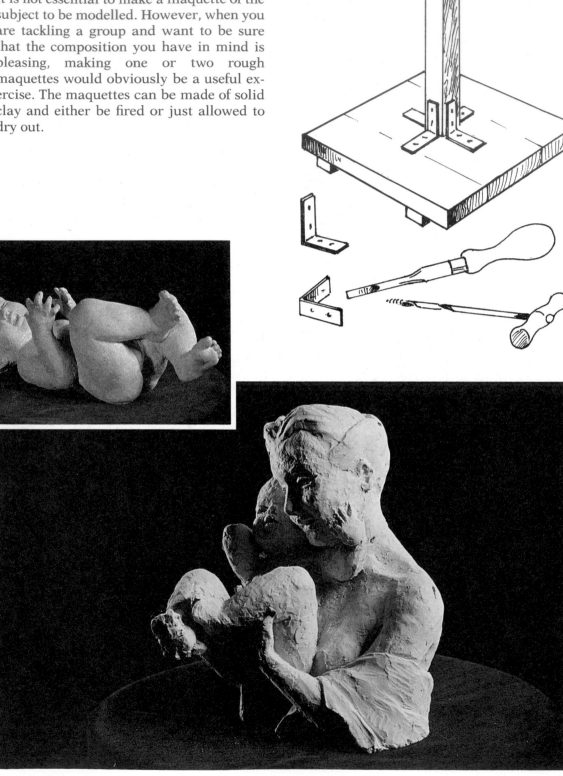

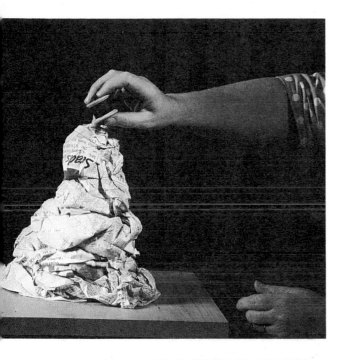

STAGE ONE

The height of this finished group is 15″. A 14″ board was selected with a 12″ wooden peg. The general shape of the mother was made by wrapping paper around the peg and securing it with cotton thread.

With clay that is in good working condition, build up from the base to form a shell. Take care to pack the clay well in order to avoid air bubbles which can cause 'blowing' when the group is fired. If the consistency of the clay is correct, the process of building a firm shell is comparatively easy and, with the paper support, the clay will be quite firm enough to build upon further.

Note: Always remember to spray the clay and cover it with a plastic bag between working sessions.

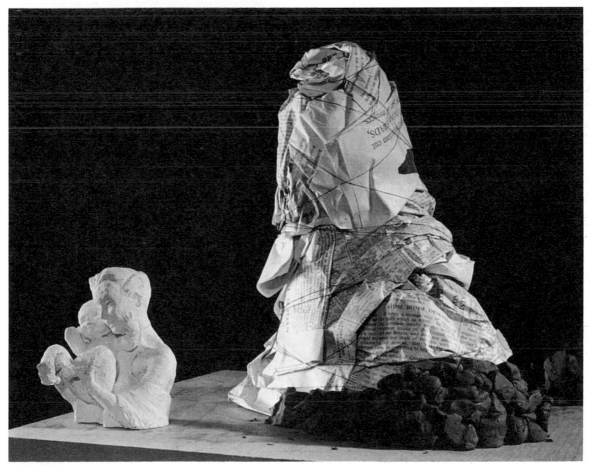

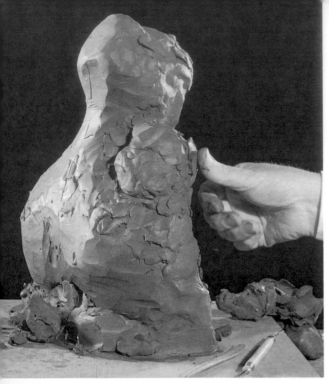

STAGE TWO

Mass in the general planes, always remembering to press the clay gently but firmly home. At this stage of blocking in, the use of a wire tool can be helpful to emphasise the many varied planes. Block in the larger figure of the mother first, completing the rib cage and the breasts before attempting to add the child. It will then be easier to add the smaller child without the danger of it being sunk too deeply into the structure of the mother.

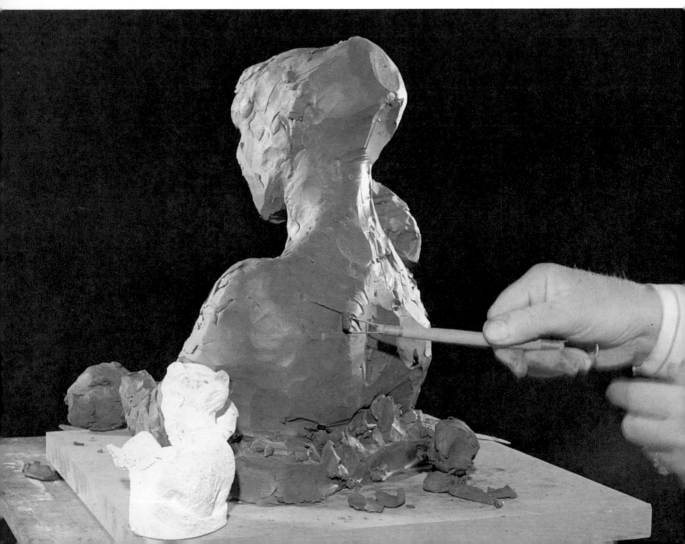

Blocking in

Pack the clay with a large curved wooden tool. When you are satisfied with the general proportions of the mother, build in the child, keeping it well up. Pay particular attention to the proportions of the baby as compared to the mother. Keep turning the group and bring it up to a consistent standard all the way around. (In a more ambitious piece of this kind, it is essential to have all the figure proportions in their simplest forms before any more complicated detail is attempted.)

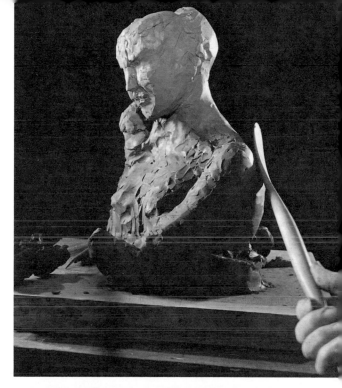

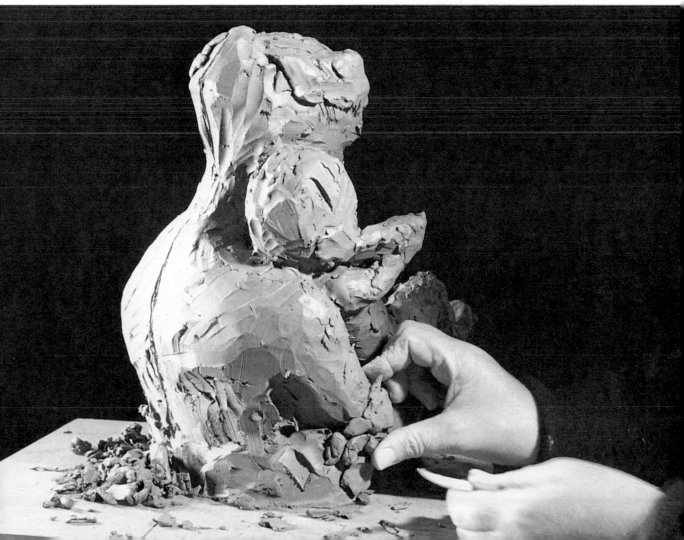

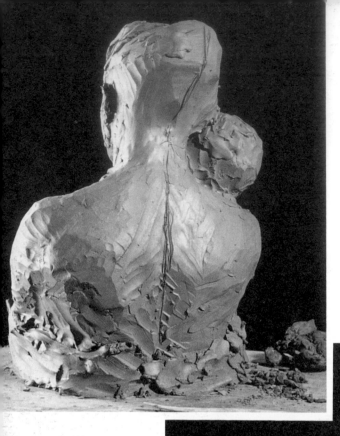

STAGE THREE

When the main pose and the general proportions of the group are satisfactory, begin to model the smaller forms. In this example, observe the feeling which the sculptor has, at this early stage, already given to the group. The sympathetically modelled tilt of the mother's head and the gentle touch of the child's hand on her face which, contrasted with the vigorous position of the child, combine more than one emotion in the relationship.

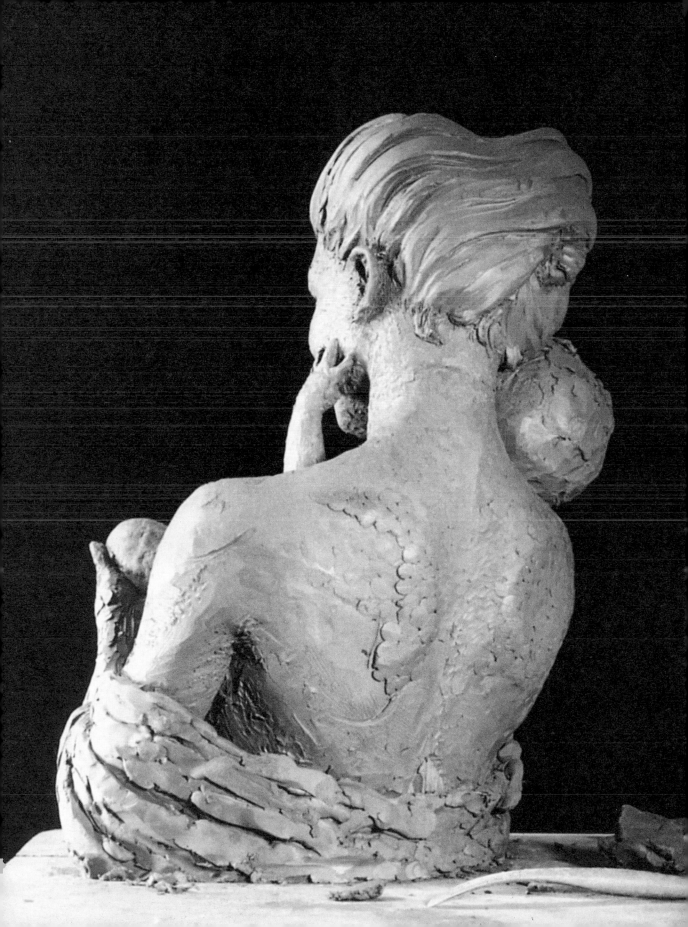

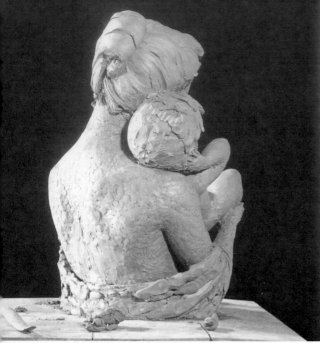

STAGE FOUR

The group is now approaching the finished state and the work should be continually turned while the smaller forms are gradually enriched and brought to the same standard all the way around. The greater the concentration and control at this stage, the more alive the group becomes.

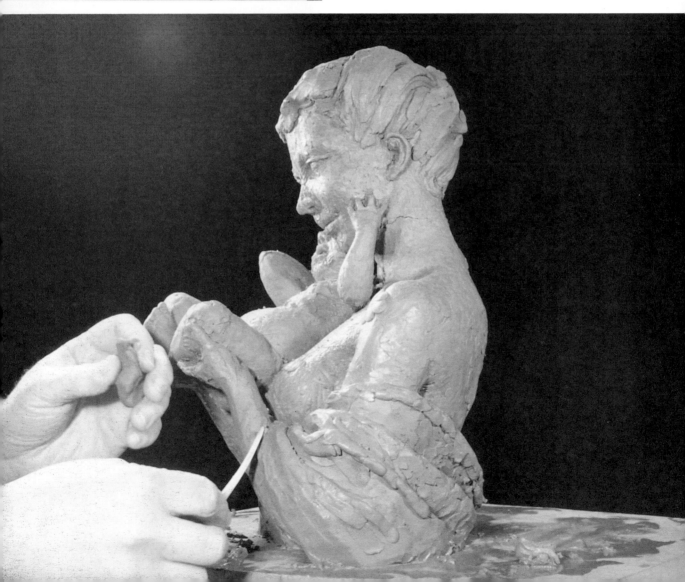

STAGE FIVE

The back view of the group, though
simpler, should show the same degree of
form and finish as the rest of the modelling.
The drapery has now given the model a
very satisfactory base and at the same time
enhanced the whole composition.

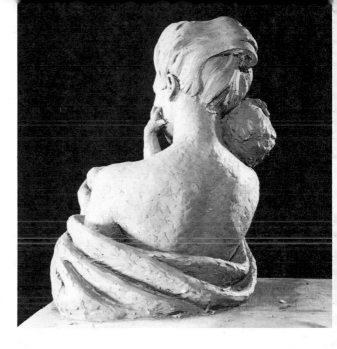

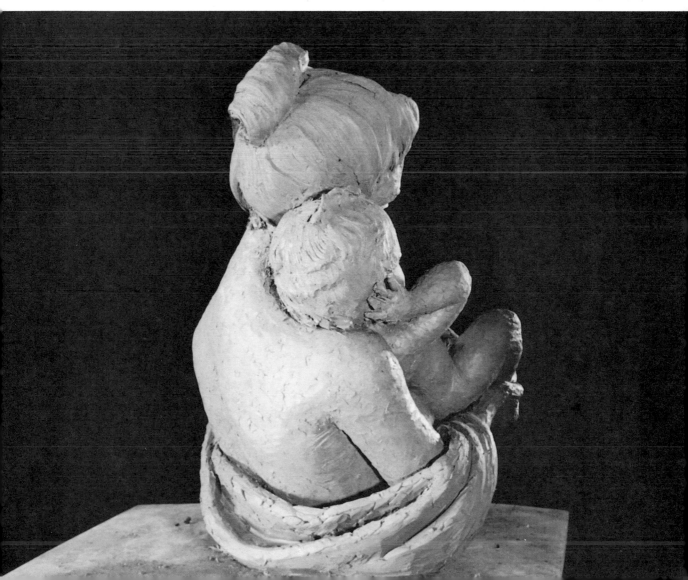

Observe the contrast between the baby's light touch on the face with the strong support the mother's hands give the leg and foot of the child. This group could have been taken to finer detail but since an even, spontaneous standard had been reached, it seemed the right moment to finish modelling.

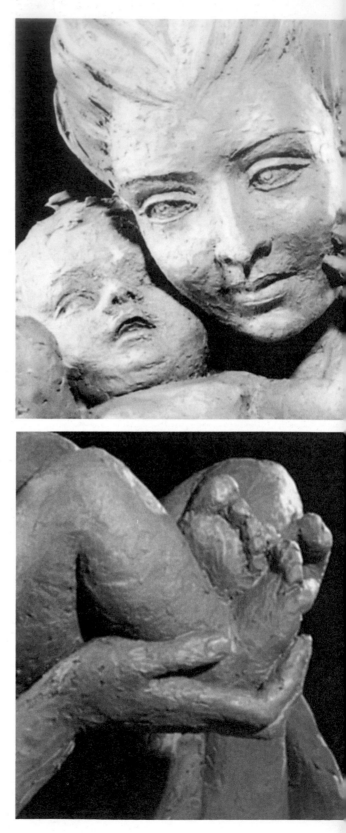

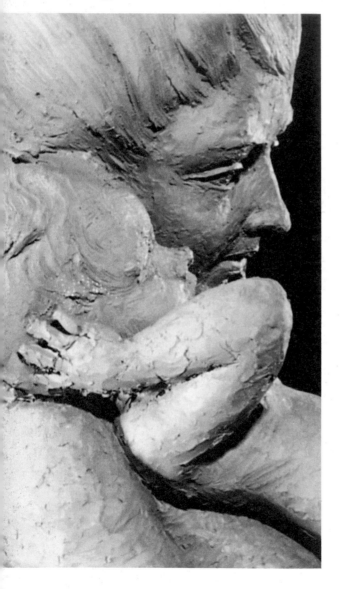

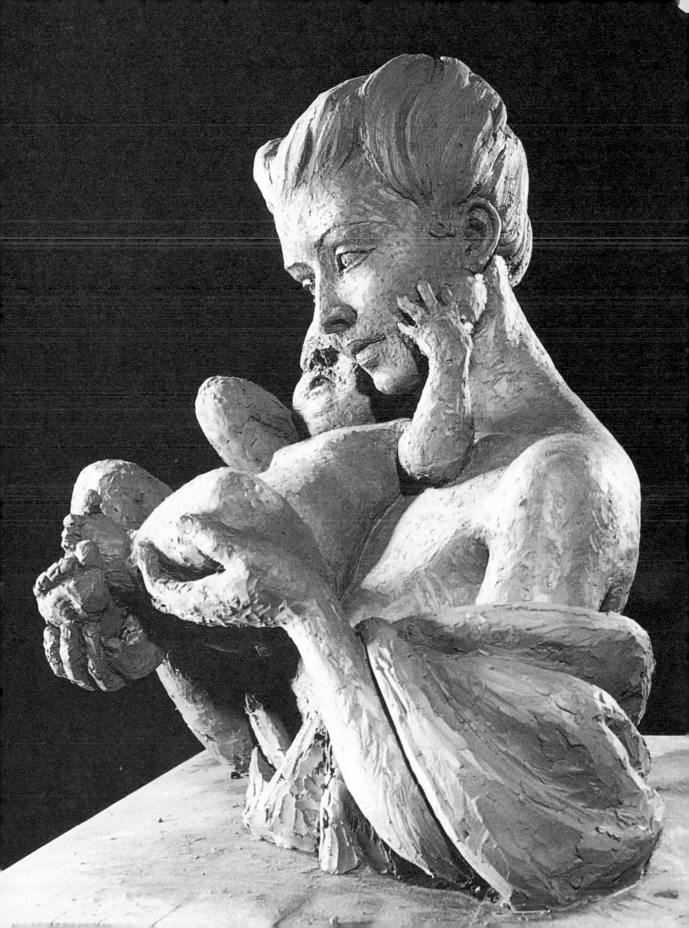

PREPARATION FOR FIRING

The group should now be allowed to become leatherhard. This process must never be hurried. First leave the plastic covering loose over the figure so that the air can circulate. Then remove the plastic and place the group in a cool position until it slowly dries enough so that it is possible to handle the clay without damaging the modelling.

Capping

A complex composition is always bound to need some correction to the thickness of the clay. In this example, it was decided to cap the head of the mother, making it possible to even the clay down into the top of her head and neck and at the same time into the baby's head. With the wire cutter, a clean cut was made. The cut was kept in the hair modelling so that it would be easier to touch up when the cap was replaced.

Lifting the cap

When the cut has been made, carefully remove the cap from the head. Snip away the paper as necessary. Then carefully place the cap on a plastic covered cushion. Using a potter's coiler and a wire tool, hollow out the cap to an even thickness. Cut away the paper around the top of the peg (in the main part of the figure) down into the head and neck as far as possible. (Any paper left in the figure will burn away at the firing stage.)

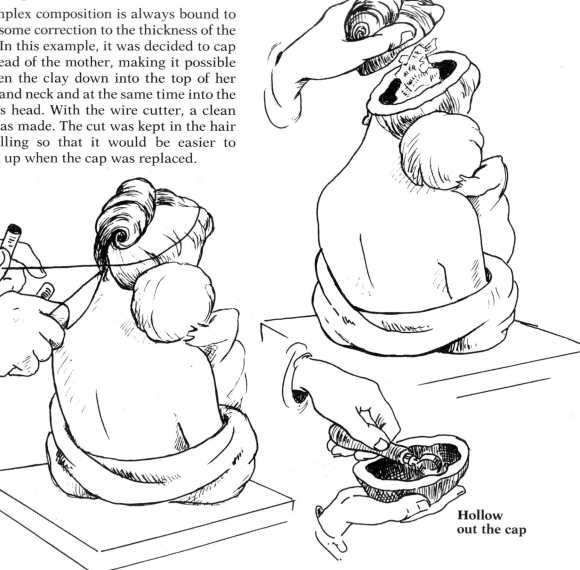

Hollow out the cap

112

Removing from board and hollowing out

With a little water on the board and a knife slid under the base of the group, lift the modelling from the board. Place the group on its side on a plastic covered cushion and hollow it out as evenly as possible from the base upwards. Then place it upright on a clean board. Check the head and the baby's face. Add some clay into the mother's neck for strengthening if needed. The baby's hands and limbs if not too thick can be fired solid.

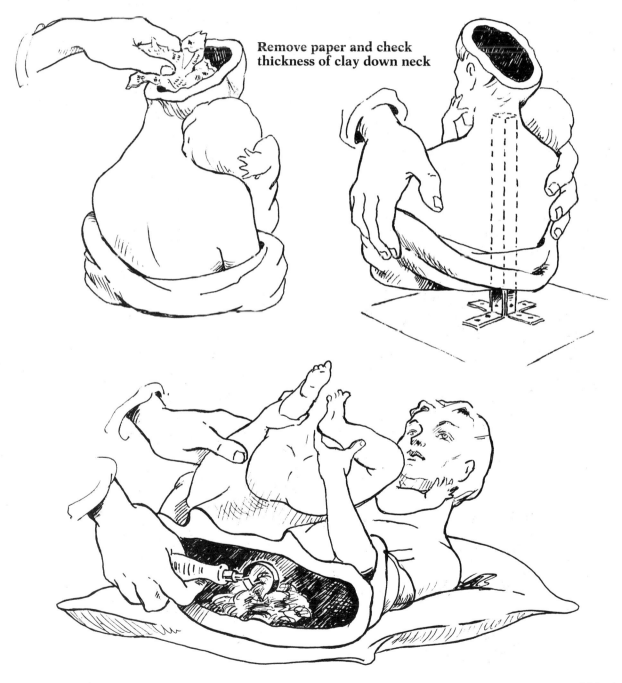

Remove paper and check thickness of clay down neck

Replacing cap and completion

Score the edges of both pieces with a metal tool and brush slip onto them. Put the cap onto the main part of the figure and gently but firmly squeeze the clay into position. When the clay has dried a little, use a tool to work the clay so that the seam can no longer be seen in the hair. The group should be pierced with a needle-like tool to allow for the circulation of air during firing. The group should then be allowed to slowly dry until it is completely dried and ready for firing (see p. 98).

FIRING AND MOUNTING

After the group has been fired, you may want to mount it. See p. 98 for ideas on how to do this.

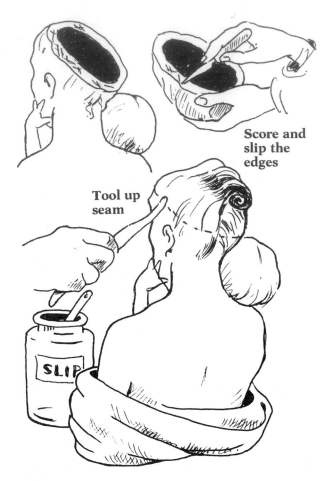

Score and slip the edges

Tool up seam

SLIP

Other Materials

There are other materials that can equally well be used for moulding and casting such as ciment fondu, fibreglass, silicones and vinyls. If you understand the basics of using plaster of Paris, you should have no trouble with these other materials. All of these materials can be obtained from sculptors suppliers (see list on p. 127). Much information and advice can also be obtained from sculptors suppliers and the suppliers of resins. Below I give just some general comments on other materials that can be used.

CASTING MATERIALS

Ciment fondu

This is a special concrete material much favoured by sculptors. It can be cast into plaster or vinyl moulds. It can be obtained in either white or darker colours so that the sculptor can mix them to obtain just the colour required. A stone or bronze-like effect can also be obtained.

With a knowledge of moulding in plaster of Paris, adapting the filling in ciment fondu should prove quite straightforward.

This material is slower to set than plaster and the moulds need to be soaked and kept damp throughout the process. Due to a chemical reaction between the plaster mould and the concrete cast, no parting agent is necessary, and an attractive bloom is left on the cast. This can be removed, if wished, by washing and waxing.

Mixing proportions should be consistent. A standard mix is:

Ciment fondu	2 volumes
Dry sand	6 volumes
Water	1 volume

Thoroughly mix the cement with the dried sand. Small quantities can be mixed in a tin or plastic bowl. Stir in the water until the mix reaches a uniform colour. Paint the inside of the mould with a coat of this material. This first coat is known as a 'goo'. Goo for an indoor sculpture such as a portrait can be a mix of neat cement with just enough water to give it a thick cream-like consistency. For outdoor sculptures, mix two parts of sand to one of cement with just enough water to make it workable with a brush. Never add water when the mix becomes unworkable.

Care must be taken when filling the plaster mould. Make sure that the mould has been thoroughly soaked but remove any pools of water with a sponge. (Since the plaster mould will be wet for a long period, it would be useful to support it with a metal tie bar so that the mould doesn't warp. These ties can be removed just before assembling the pieces of mould.) Then brush in the first 'goo' coat to approximately a $1/16''$ layer. Follow this with a coating of the standard mix bringing the layer up to a $1/8''$ thickness. Make this second coat thicker over cavities so that the surface is smooth. This second coat can be pressed in with your fingers. Then tamp down the coating well with a wooden, round-ended tool (such as a tool handle) to bring all the water to the surface. (The addition of a glass fibre matt can greatly strengthen the cast. This can be tamped in with another goo mix.) Check that the seams are level and smooth so that when the mould is later assembled, there will be a close fit. When the casting is complete and the concrete is firm, spray it with water and keep it wet for 24 hours with wet cloths and a polythene cover.

Fibreglass

Fibreglass is the term commonly used for the combination of polyester resin reinforced with glass fibre. It is strong, light in weight and can be cast into sealed moulds of plaster of Paris or into flexible moulds of vinyl or silicone which have been supported with 'jackets' made from plaster or fibreglass. No separator is needed when resin is applied to vinyl or silicone moulds.

First mix the resin with an accelerator (if there isn't already an accelerator in the purchased resin). Then add a catalyst. This first coat is called the Gell coat. It can have various fillings which will colour the resin pigment. For instance, a filling of plaster will give an opaque white surface. Stone and marble dust give excellent results as does the addition of bronze powder, brass and copper. This latter combination is known as Cold Cast Bronze (see p.118). When the first gell coat with the chosen filling has been applied to the mould, the filling will sink to the surface of the mould. Allow the first coat to set and then apply a thin coat of resin (without filling) over it. Tamp it down into the resin glass fibre matt which has been cut into convenient, small pieces with a resin-filled brush. Any untidy bits of glass can be tamped down with a brush filled with brush cleaner.

Should the modelling have crevices or undercuts, first fill these with part of the second resin mix and finer pieces of 'chopped glass'. This will fill the areas that might otherwise have been 'bridged' by the longer pieces of glass matt and thereby strengthen the cast.

Never hurry when using fibreglass and resins. Always have all the necessary materials laid out in order. Have the fillings already weighed. If several small mixes are needed, have the resin weighed into suitable containers (clean tins are excellent). Then add the catalyst as needed. The resin should ideally set in 20 minutes. Never mix more resin than can be used well within the curing time. Always add fillings last and mix again.

Temperature and humidity make a great difference to the speed a resin mix will cure or go hard. The ideal temperature would be 67°F. Do make a small test before starting because if the temperature is too low, it can take hours to 'go off' and there is nothing for it but to wait. If the mix is too speedy, it can harden before it can all be used. Keep a notebook of every mix. Note the weather or exact temperature, quantities weighed out etc., and speed of setting. This can be useful when wishing to repeat good results as well as avoiding unsatisfactory attempts.

FLEXIBLE MOULDING MATERIALS

For sculptors there are two very suitable flexible moulding materials – Vinamold which is a hot melting vinyl compound and Silicone which is a cold curing rubber and though it is more expensive, it is generally preferred.

When ordering either of these materials, ask for data regarding methods of use, temperatures and catalysts needed etc. Many of the suppliers will provide you with technical booklets which are a great help.

Vinamold

Vinamold is purchased in fairly thick, flat slabs. There are different grades of Vinamold which come in different colours and have different melting temperatures. The slabs need to be cut into strips with a sharp knife and then into small pieces with scissors. The pieces then need to be melted down until they have reached a pouring consistency. The suppliers will tell you what the appropriate temperature is for this. You should obtain a good thermometer for testing the temperature. A medium soft vinyl could melt at 150°–170°C but it should not be poured until it has cooled to say 140°–150°C. Great care should be taken not to heat the vinyl above the manufacturer's recommended temperature because excess heat can spoil the vinyl. (Moulds can be cut up again and again for use.)

There are special melting pots like double saucepans with cast iron bases and large electric pans which are excellent for melting the vinyl. However, for reasonably small amounts of vinyl, a very thick based pan (pressure cooker thickness is ideal) can be used on a gas or electric ring with an asbestos mat between. Put small pieces of vinyl into the pot until the bottom of the pot has a ¼" thick melted coating. Then continue to slowly add pieces of vinyl until the required quantity is melted. Don't add too much at a time because this will cause the temperature to drop. Stir the melt constantly. It is a good idea to wear a mask when stirring the melt because the vinyl gives off unpleasant fumes. Check the temperature of the melt with a thermometer before pouring. Since the vinyl must be poured at once, it is advisable to have the piece to be moulded ready for use.

Testing

When using Vinamold for the first time, it is a good idea to do a test to see how it works. Take a small, flattish piece of clay modelling and put it on a board. Surround it with a band of plasticine or clay that is approximately ¼" away from the piece. Make sure that the band is firmly supported around the sides. The band must be higher than the piece to be moulded. Pour the hot Vinamold onto the board (not over the top of the clay) and allow the Vinamold to rise up until the whole is covered. Do this in one pouring. When set, remove the band and make a plaster of Paris jacket or case. When the jacket is hard, turn the mould over and remove the clay. The mould is now ready to use for casting. Several casts can be taken from the mould.

Silicone rubber moulds

Silicone rubber is a liquid, cold moulding material. It needs to be mixed with its particular catalyst. This can be done by hand,* but since it needs to be mixed for at least 10 minutes, it is useful to do it with a mixing rod in an electric drill. The mixed liquid rubber can be poured when using the box method that is, when a high 'box' of clay or wood is placed around the piece to be moulded and silicone poured in to fill the box. However, since it is expensive, where possible it is better to paint it onto the sculpture with a brush. It is a good idea to surround the model with a band of plasticine. This will contain the silicone that runs down the model initially. As the silicone thickens, it can be gently moved over the model with a brush or a pallet knife to ensure that the coating is of an even thickness. Another coat can be added if necessary when the first coat is set though it must still be tacky to the touch. Clay bands or shims can be used to separate sections (see p. 26) though the silicone should be applied in one go. Make a plaster jacket to support the flexible mould. Then use the mould for casting as described under Vinamold.

* Be careful not to get the catalyst on your skin. If you do, wipe it with alcohol and then wash the skin with soap and water.

RTV Silicone moulding materials

RTV means room temperature vulcanising. Silicone means that it is a synthetic base rubber (unlike rubber from a tree). These moulding rubbers have very low shrinkage characteristics on curing and have the quality of an almost non-stick surface (unlike real latex).

Silicone rubbers fall into many categories. The ones useful to sculptors are usually white liquids that require a catalyst added at between 4% and 10%.

Silicone always gives optimum flexibility and tear strength when well mixed to manufacturers' specifications.

Suppliers make good products which are very fluid for application to fine detail. It is advisable to use a formulation that accepts an addition to make it more thixotropic (not filler powder or aerosol). These additions up to 5% will change the consistency to that of butter for application on to vertical surfaces.

Note these points:

1 Turpentine will clean the brushes.

2 Water with a little soap will smooth a surface before it is quite cured.

3 To repair torn silicone use bath caulking material.

4 Use acetone to clean surfaces.

Recipes

COLD CAST BRONZE

A basic recipe for a gell coat.

1oz resin (usually has accelerator already added)

1 extra drop of accelerator (possibly more)

2cc of catalyst

1½oz Bronze powder

Mix the resin and any accelerator first. Then add the catalyst, mix and *lastly* add the bronze powder and mix again.

Never mix until ready to use. Always add the filler last.

Make tests aiming at a curing time of 20 minutes.

STONE OR MARBLE FINISH

Use resin recipe as above.
Use stone or marble dust in place of bronze. As soon as the cast sculpture is released from the mould, rub the surface down well with fine steel wool. This will remove a thin film of resin which will be covering the bronze or stone filling. If this is not done at once, it becomes very difficult indeed to remove and spoils the surface finish. (The surface of bronze is very hard and will not be damaged.)

The bronze sculpture will then need waxing and polishing (rub until it shines). A very light touch of gold (tubes for picture frames) put on the thumb and lightly touched over high spots can help. One is inclined to overdo this but it is easily removed again with a little more wax polish.

Necessary equipment

scales
resin
accelerator
catalyst and syringes 0.1
chopped glass matt
finely chopped strands of glass
brush cleaner (cheaper than acetone)
tamping brushes
plenty of tins for mixing and brush cleaning
waste bin or box
newspaper
bronze powder
brass powder
copper powder
steel wool
separators
Barrier cream for hands so that they don't get covered in resin.
If at first they do, Xerocleanse will help if it is rubbed onto the hands before washing.

Other Examples of the Author's Work

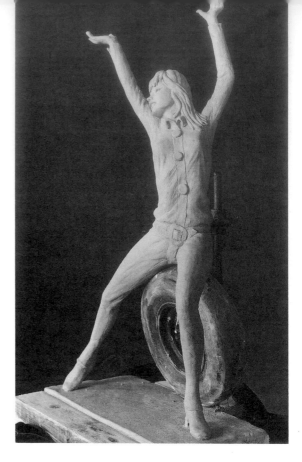

'Mini Light Maggie' (*right*)
For Motor Show, advertising Mini Light racing wheels.
Produced in pure bronze and other materials at Artist's own studio in Surrey.

Eagle (*below*)
One of a pair for a private estate.
Produced in stone filled with glass fibre (silicone moulds with glass fibre jackets) at Artist's studio in Surrey.

Embryo Water Creature (*left*)
Made in Rome for the film *The Rift* by Dino de
Laurentiis.

Starting the Dragon Head, 'Falcor' (*below*)
Made in Bavaria Studios, Munich for the film
The Never Ending Story I. The whole dragon
was 40 feet long.

Mural
Made for the foyer of the Rees office building.
The mural is 9 feet long and it was produced in
cold cast bronze at the Artist's studio in Surrey.

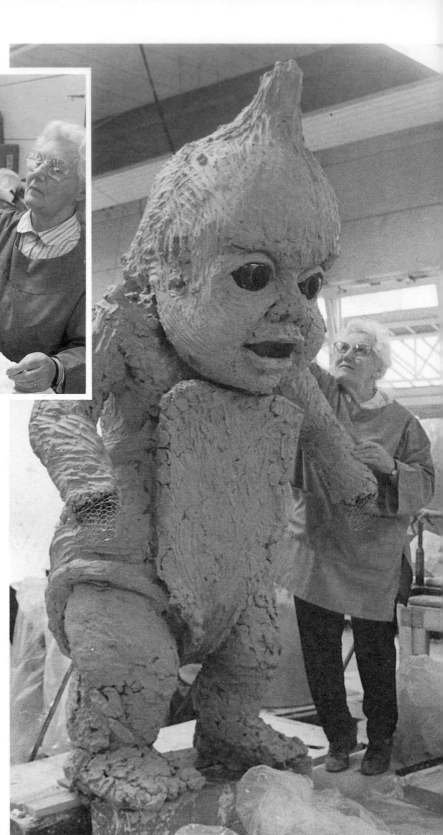

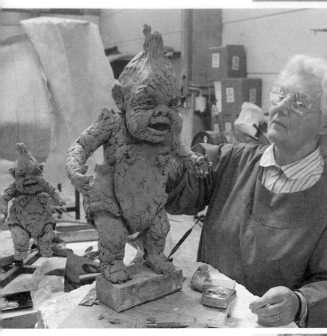

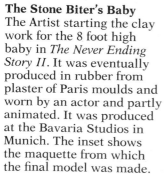

The Stone Biter's Baby
The Artist starting the clay
work for the 8 foot high
baby in *The Never Ending
Story II*. It was eventually
produced in rubber from
plaster of Paris moulds and
worn by an actor and partly
animated. It was produced
at the Bavaria Studios in
Munich. The inset shows
the maquette from which
the final model was made.

124

Disintegrating Head (*left*)
Made for the film *Life Force*,
which was produced at
Elstree Studios in England.
The rubber mask was made
from a clay model.

Dragon, 'Smerg' (*below*)
Made for the film, *The Never
Ending Story II*, at the
Bavaria Studios in Munich.
The clay model was made
from Patrick Woodroffe's
design. A rubber model was
made which was animated
and made to breath fire.

Television Commercial
(*above*)
Made for Schweppes. The
second 'President' being an
actor made up to match the
stone effect, who winks at
the sound 'Schhh'. It was
made of stone filled fibre
glass in Spain.

Masks (*right*)
Made for the Barcelona
Expo 1992. It was made in
plaster of Paris in Spain.

LIST OF SUPPLIERS

Plaster

British Gypsum Ltd
Jericho Works
Bowbridge Road
Newark, Notts. NG24 2BZ, UK
01636–703351

Cookson Ceramics Ltd
Uttoxeter Road
Meir, Stoke-on-Trent ST3 7XW, UK
01782–599111

Laguna Clay Company
14400 Lomitas Avenue,
City of Industry, CA 91746, USA
800–452–4862

Whitfields Minerals Ltd
Whitfield House
10 Water Street
Newcastle-under Lyme,
Staffordshire ST5 1HP, UK
01782–711155

Clays

Axner Pottery Supply
PO Box 621484
Oviedo, FL 32762 USA
407–365–7057

Bath Potters' Supplies
2 Dorset Close,
East Twerton, Bath BA2 3RF, UK
01225–337046

Briar Wheels and Supplies Ltd
Whitsbury Road
Fordingbridge,
Hampshire SP6 1NQ, UK
01425–65991

Potclays
Brickkiln Lane
Etruria, Stoke-on-Trent ST4 7BP, UK
01782 219816

Potterycrafts Ltd/Reward Clayglaze
Campbell Road
Stoke-on-Trent ST4 4ET, UK
01782–745000

Tucker's Pottery Supplies
15 West Pearce Street
Richmond Hill,
Ontario L4B 1H6, Canada
905–889–7705

Other moulding products

Alec Tiranti
27 Warren Street
London W1P 5DG
0171–636–8565

Kingfisher Ceramics Service
Bycors Road
Heathcote Works
Burselm, Stoke-on-Trent ST6 4EQ, UK
01782–575254

J. W. Radcliffe & Sons
Rope Works
Shelton New Road
Stoke-on-Trent ST4 6DJ, UK
01782–611321

Index